Mexican American Baseball in the San Fernando Valley

"In This Part of Life Called Baseball"

On Monday to the orchards and fields we go
Digging and planting
Picking and packing
Vivir para trabajar
Trabajar para vivir

On Sunday to Santa Rosa Church we go
Mothers and Fathers
Sisters and Brothers
Praying and giving thanks
Taking nothing for granted

After church to Las Palmas Park we go
The dirt diamond is our treasure
A wooden bat and string ball
Hitting and running
Sliding and scoring

Our familia is cheering us to go
Winning or Losing
But ours is never lost
For we have perseverance
Not discrimination but validation
In this part of life called baseball

—Victoria Carrillo Norton
Spring 2015

Front Cover: William F. Miranda played second base for San Fernando High School, the Illinois Cleaners, and the San Fernando Missions. He was a descendant of one of the escort soldiers from the second Anza Expedition to Alta California in 1775. He served in World War II and worked for Lockheed until he retired. (Courtesy of William F. Miranda.)

Cover Background: The Pacoima Athletics formed after World War II and played every Sunday at Pacoima Park until the early 1950s. Team ace Pete Prieto (first row, third from left, wearing jacket) worked as a police officer for the Los Angeles Police Department and was the assistant recreational director for Pacoima Park in the late 1940s. (Courtesy of Pete Prieto.)

Back Cover: The 1937 Van Nuys Texas Grocery team lines up at the Van Nuys ball field. The Ruiz sisters—Beatrice, Virginia, Lillian, and Alice—come from a long-standing baseball and softball family. Their aunt Mary Cano played for a Simons Brickyard baseball team in Montebello in the 1910s. (Courtesy of Virginia Ruiz Durazo and Jackie Durazo Murphy.)

Mexican American Baseball in the San Fernando Valley

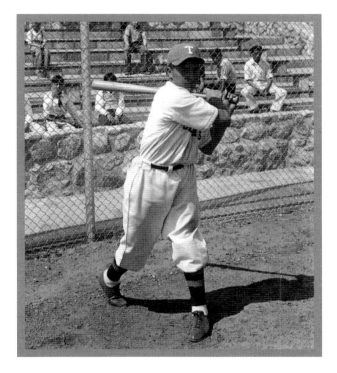

Richard A. Santillán, Victoria C. Norton,
Christopher Docter, Monica Ortez, and Richard Arroyo
Foreword by Everto Ruiz

Copyright © 2015 by Richard A. Santillán, Victoria C. Norton, Christopher Docter, Monica Ortez, and Richard Arroyo
ISBN 978-1-4671-3452-1

Published by Arcadia Publishing
Charleston, South Carolina

Printed in the United States of America

Library of Congress Control Number: 2015948007

For all general information, please contact Arcadia Publishing:
Telephone 843-853-2070
Fax 843-853-0044
E-mail sales@arcadiapublishing.com
For customer service and orders:
Toll-Free 1-888-313-2665

Visit us on the Internet at www.arcadiapublishing.com

For my grandparents, José and Benita Santillán, Francisco and Savina Oviedo, and to my incredible wife, Teresa, who has brought nothing but sunshine and happiness to my life.
—Richard S.

For my beloved parents, Alice "Budgie" Lyon and Albert Reyes Carrillo, both born and raised in the old town of San Fernando.
—Victoria

For my beloved grandparents Paul and Rachel Cruz, who met at the tomato packinghouse in old town San Fernando in 1920 and celebrated 68 years of marriage in the city of San Fernando, and especially my wife, Ruth, who supported me through this amazing project.
—Richard A.

For the tremendous Docter family—I love you all.
—Christopher

To my father, Ray Ortez, for his dedication and love of baseball and softball during the Old-Timer's Era, 1930s and 1940s. To my mother, Florence Edith Ortez, for her support of Dad's ball career and for preserving those memories for our family.
—Monica

For my tio Rubén Ruiz, my brother Rubén L. Ruiz, and my neighbor Epimenia "Pepper" Delgado, who gave their all on the baseball field.
—Veto

CONTENTS

Foreword		6
Acknowledgments		7
Introduction		8
1.	The City of San Fernando	9
2.	The San Fernando Valley	33
3.	Transnational and Military Baseball	53
4.	The Golden State	75
5.	Orange County	97
6.	Field of Dreams	113
Bibliography		126
Advisory Board		126

FOREWORD

"Tira la bola, Bárbula, tírala." This was the animated exclamation that my older brother, Ruben, would frequently shout to his teammate in his dreams, revealing the degree to which playing baseball consumed him. This manifestation of his enthusiasm for the game was no doubt a common occurrence in many families in the San Fernando Valley, where young men and women constantly lived and breathed baseball and softball.

The city of San Fernando's premiere baseball diamond, well known in the Los Angeles area, sat alongside the very railroad tracks that literally separated the Mexican American barrio from the rest of the community. While my hometown took decades to creep out of the practice of residential segregation and discrimination in the workplace, it was on the baseball diamond at San Fernando Recreation Park that Mexican American ballplayers could compete on a "level playing field." There, you were judged by your athletic ability and talent rather than your ethnic background. It was there that my dad would go on Sunday afternoons and join friends, relatives, and, on occasion, talent scouts from professional teams, to watch my brother, uncles, and neighbors play baseball.

Mexican American Baseball in the San Fernando Valley is yet another publication in a series of Mexican American baseball books that reveals our community's longtime involvement and unrestrained love with this American pastime through previously unpublished photographs, astonishing stories, and incredible documents. As shown in the following pages, this was not only a competitive and entertaining experience in the local community, but it also gave Valley ballplayers the unique opportunity to travel and play other teams, from the San Joaquin Valley to the Mexico border. We are fortunate and grateful to those families and friends who made these extraordinary photographs and wonderful memories of loved ones available to us for this publication.

—Everto Ruiz
Professor of Chicano Studies
California State University, Northridge

ACKNOWLEDGMENTS

The foundation of this project to publicize the rich history of Mexican American baseball and softball in the San Fernando Valley is due to the remarkable work of the Latino Baseball History Project at California State University, San Bernardino (CSUSB). Others who supported this effort include the following individuals and staff and CSUSB's John M. Pfau Library: Dean Cesar Caballero and Sue Caballero, Jill Vassilakos-Long (head of archives and special collections), Iwona Contreras, Ericka Saucedo, Amina Romero, Carrie Lowe, Manny Verón, Brandy Montoya, Hayley Parke, John Baumann, and Stacy Magtedanz.

The authors are indebted to the players and families who provided the treasures of photographs and extraordinary oral histories. These dedicated individuals and groups include the following: Estella Lyon Maas, Joe Govea, William F. Miranda, Alice Cruz Bacon, Della Ortega, Maria Carrillo, Mary Jo Moss, Andy Alba, Kristy S. Bórquez, Robert Bórquez, Marianne Castro Lawson, Sylvia Verdugo Ramírez, Geraldine Reyes Núñez, Everto Ruiz, Carolyn and Gary Sánchez, George and Miyeko Tamura, Lorrie Carrillo, John Fonseca, Sandra Savala, Rita Delgado, James V. Verdugo Jr., Kimberly Norton, Cecilia García, Fred C. Rico, David and Julie Gonzáles, Pinney García Jr., Christine "Pinki" Puga, Karole Obrikat, Virginia Barragán, Francisco "Chico" Cruz Sr., Paul and Rachel Cruz, Pauline Cruz Arroyo, Hazel Cruz Lemus, Betty Cruz Woodson, Dorothy Cruz Hatley, Cecilia Cruz Arroyo, Elaine (Arroyo) and Gene Bond, Erica Arroyo, Jennifer Arroyo, Grace and Robert Ayon Sr., Paul Ruelas, Cecil and Victoria Cruz, Francisco Cruz Jr., Robert Cruz, David Cruz, Michael Bacon, Theresa Alicia Bacon, Elvira Camarillo Orozco, Julie Orozco Ruelas, Jeffrey Lawerence Cornejo Jr., Jesús Ruiz, Rita and Rubén R. Ruiz, Stella and Rubén J. Ruiz, Jesse H. Ávila, Joffee García, Tommy and Linda Tapia, Rudy Aragón, Ramona Cervantes, Richard Docter, Mary Jane Muro, Pete Prieto, Tony Servera, Alex Sáenz, Rosie Alderete Rico, Cece González, Olivia Ruiz, Virginia Barry, Marie Acebo, Michael Norton, David García, Moses Guzmán, John Martínez, Julie Fernández, Joe Fernández, Armida Encinas, Speedy Gonzáles, Rachel Jiménez, Art Castañeda, Marty Cortinas, Bill Skiles, Skip Wrightson, Margaret Amescua, Theresa Tresierras Durazo, Ray Barraza Jr., Lorraine Barraza, Benny Salas, Connie Lugo Ferrer, Gloria Montañéz-López, Eddie Prieto, Socorro Cano, Mario Cano Jr., Kasey Khaghany, Rosie Díaz, Bob Calzada, Gena Avalos Calzada, Gloria Gonzáles, Armando Valencia, Richard F. Encinas, Linda Encinas Hernández, Terry Hernández, Rita Hernández Ontiveros, Jackie Durazo Murphy, Virginia Ruiz Durazo, Arnold Durazo, Ray Barraza, Ron Regalado, Minnie Moreno, Tony Dávila, Bobby Lujan, Dick Santoyo, John Lara, Jerry Nieblas, CeCe Nieblas-Vásquez, Teeter Romero, Mrs. Eddie Reyes, John G. Húrate, Paul Salazar, Maria T. Solís-Martínez, Jim Segovia, Richard Méndez, Jodi Della Marna, Orange Coast College Archives, Little Landers Sunland–Tujunga Historical Society, San Fernando Valley Historical Society, A. Bartlett Giamatti Research Center–National Baseball Hall of Fame and Museum, San Fernando Museum of Art and History, St. Ferdinard's Fifty-Plus Group, and the San Fernando Recreation and Park Department. We recognize again our in-house editor, Elisa Grajeda-Urmston, for her tireless and professional work; and our utmost appreciation goes to our technical consultant, Monse Segura. Last but not least, our heartfelt gratitude goes to Arcadia Publishing and to our remarkable and patient contacts there—Michael Kinsella, Tim Sumerel, and Jeff Ruetsche.

INTRODUCTION

The San Fernando Valley is located north of the Los Angeles Basin, surrounded by the Santa Susana, Santa Monica, San Gabriel, and Verdugo mountain ranges. The region began as a handful of sleepy agricultural towns that has exploded into one of the most famous suburbs in America, containing over two million residents. Mexicans hold a storied presence in the area, dating long before statehood in 1850. By the early 20th century, thousands of Mexicans from the Southwest and Mexico joined longtime Mexican Californians to form vibrant neighborhoods in the few Valley towns. Many worked in citrus orchards, packinghouses, ranches, and railroads, while others started small family businesses and companies in the construction, transportation, produce, and disposal industries. The Mexican American population was vital to the early agricultural and industrial growth of the San Fernando Valley.

Mexican American communities in the Valley were linked through family ties, occupations, and social activities, such as *jamaicas* and sports. They lived in an incredibly tight-knit environment where everybody knew everybody. Mexican Americans have played baseball in the San Fernando Valley since the late 19th century. Through baseball and softball games, different barrios maintained connections with each other. On weekends, men's and women's games attracted hundreds of spectators. They gathered at vacant lots, ringing their cars around the field of play to form a makeshift outfield barrier, and they packed the grandstands of professional-quality baseball fields.

Extensive travel to Central California and into Mexico allowed players to network with other regions. Games between teams from the San Fernando Valley and visiting Mexican teams acted as important diplomatic events, at times bringing together politicians, such as the Los Angeles Mexican consul and the California governor. Furthermore, Mexican Americans played alongside white, black, and Japanese Americans.

Baseball and softball were central to numerous Mexican American families. It was not unusual for all members of a family to play on teams. These athletic families promoted female participation in sports that transcended gender norms of the time and established baseball and softball traditions that have lasted generations. Their descendants continue their legacy today, competing in youth, high school, college, and professional leagues.

1

The City of San Fernando

The origin of the San Fernando Valley is found in the historic city of San Fernando, a direct outgrowth of nearby Mission San Fernando. In 1874, San Fernando's founding was accelerated by a land boom in Southern California, and the Southern Pacific Railroad enabled travel to the north. The area was rich with its own water source and a climate perfect for cultivating vegetables and fruits. Farms and orchards were in abundance. Citrus packinghouses and the canning company provided work for many.

In the early 1900s, families emigrated from Mexico, fleeing the revolution. In addition, Mexican American families moved from Ventura and Los Angeles Counties, following family members already settled in the area. Japanese and European immigrants also settled in the city, which soon became populated with an influx of settlers.

Baseball has played a major role in the lives of Mexican Americans in the city of San Fernando for over 120 years. San Fernando established an organized baseball team in the 1890s. Some of the early players were descendants of the Californios from Mexico. Games were held at packinghouse locations. After World War I, the semiprofessional teams called the San Fernando Merchants and Missions were formed. In the 1940s, the Seattle Rainiers of the Pacific Coast League held spring training at San Fernando Park. School, church, and neighborhood teams were formed and sponsored by local merchants. Games were played near present-day Santa Rosa Church and Las Palmas Park.

The Mexican American community of San Fernando worked hard, went to church on Sunday, and then played baseball. Baseball was the vehicle that brought families and neighboring communities together. Playing softball enabled women to cross strict cultural boundaries and travel outside of their homes. Men were able to form strong bonds and develop deep cultural identity with other team members. A sense of pride helped to promote the desire for social mobility. Many learned that working together was the key to success. Some used baseball as a means to become educated.

San Fernando High School's current baseball team is composed of many Mexican Americans and continues to win city championships.

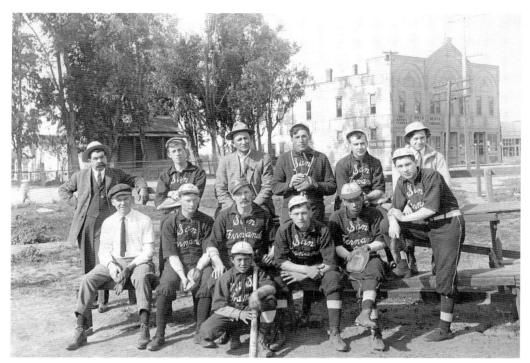

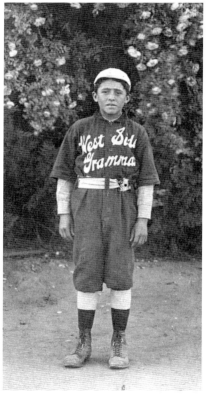

The 1909 San Fernando baseball team included descendants of Californio families, such as Edward D. Lyon (batboy), Frank Pico (second row, far left), Raul Candelot (second row, third from right), and Albert García (first row, second from right). Other players, such as Fred Nemback (first row, third from right) and William Millen (second row, third from left) married Californio women from the Lyon and López families. The team is posing in front of the Harps Hall dry-goods and grocery store. (Courtesy of San Fernando Valley Historical Society.)

Edward D. Lyon attended Westside Grammar School before San Fernando Grammar School opened in 1909. He played in baseball games against other grammar schools in the developing San Fernando Valley. After serving in World War I, Lyon worked for the San Fernando Lumber Company. He was a volunteer fireman for 25 years and rode in *Old Betsy*, the city's first motor-propelled fire truck, bought in 1920. The number of toots from the Southern Pacific roundhouse whistle directed firefighters where they were needed. (Courtesy of Victoria C. Norton.)

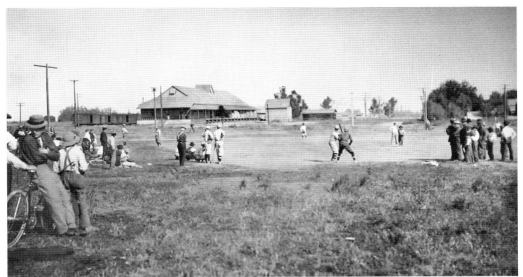

San Fernando had an organized baseball team as early as the 1890s. This 1910 game is being played in front of the San Fernando Fruit Growers Association packinghouse. One of the first in the San Fernando Valley, it was located along the Southern Pacific Railroad track between Chatsworth and Wolfskill Streets. (Courtesy of López Adobe Archive.)

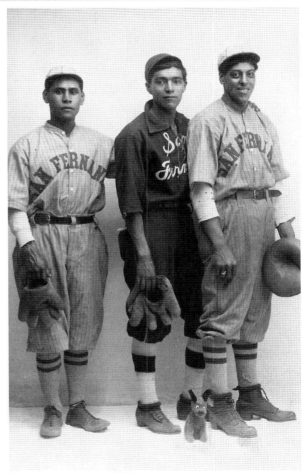

Posing here are San Fernando baseball team members Albert García (left), Vincent T. Verdugo (center), and Lawrence Saldibar. Descended from an early Californio family, Verdugo married Sallie Ortega, who had local Native American ancestry. He had a natural talent for music, playing the bugle and guitar. Verdugo served in World War I as part of the American Expeditionary Forces. He contracted tuberculosis during the war and passed away at the Veterans Hospital in Sylmar in 1931. (Courtesy of Geraldine Reyes Núñez.)

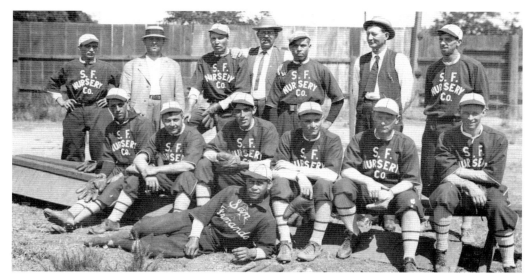

The San Fernando Nursery Company sponsored this 1915 team, including Albert García, wearing the San Fernando uniform in front. Other team members are brothers Fred (first row, far left) and Raul Candelot (first row, third from left). Their father, Pedro Candelot, was a foreman for the Southern Pacific Railroad. Paul Cruz (not pictured) was the foreman for the nursery's specimen tree division in the 1930s. (Courtesy of Pauline Cruz collection.)

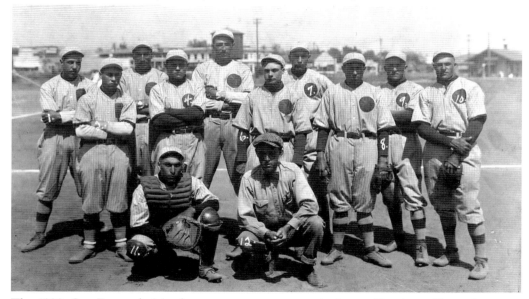

The 1920s San Fernando Merchants team was composed of sets of brothers. Shown here are, from left to right, (first row) Paul Cruz and Fred Candelot; (second row) Ignacio Pesqueira, Fred Nemback, Charles Chapman, Bill Pesqueira, and Martin Dornaleche; (third row) Refugio Samora, Frank Cruz, Raul Candelot, Cecil Cruz, and Arthur Lyon. The team was sponsored by the local business community. The San Fernando depot of the Southern Pacific Railroad can be seen to the right behind the players. (Courtesy of San Fernando Valley Historical Society.)

Some members of this 1930s San Fernando Merchants team wear Sonora team jerseys. It was common for men to play on multiple teams and travel to different areas. This squad includes Paul Cruz (first row, far left), Arthur Lyon (first row, second from left), Cecil Cruz (second row, second from right), and Manuel A. Castro (third row, second from left). The team is posing in front of the Fruit Growers Association packinghouse. (Courtesy of Marianne Castro Lawson.)

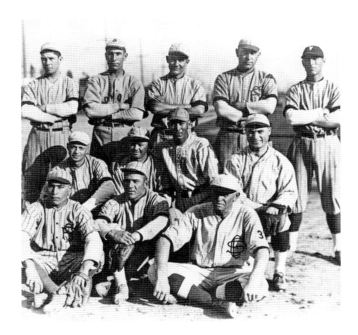

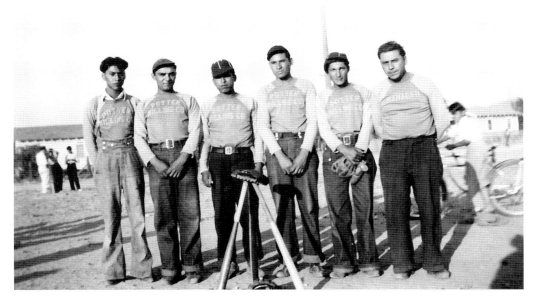

The members of this late-1930s team, sponsored by the Potter Milling Co. of Pacoima, are, from left to right, unidentified, players Joffee García, Lupe G. Hernández, unidentified, Julian Almeida, and manager Chapo Vidal. Vidal managed and coached for several other Pacoima and San Fernando teams in the 1930s and 1940s, including the Pacoima Aztecas women's team, San Fernando Missions, and San Fernando Monarchs. Players from Pacoima and San Fernando often interchanged, because of the proximity of friends and family members. (Courtesy of Della Ortega and Lorrie Carrillo.)

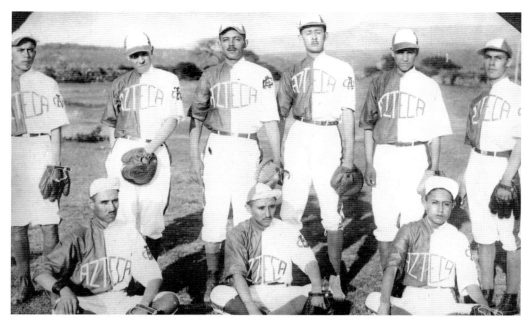

Salvador Arteaga, the catcher for the 1930s Azteca team, is in the second row, second from left. His family immigrated to Arizona from Mexico in the early 1900s, traveling on the backs of mules. Once in Arizona, Salvador's father, Jacinto, drove a team of mules hauling wood to town. Later, Jacinto and Salvador worked in the copper mines. Salvador and his wife, Maria, moved to San Fernando in the early 1930s. He continued to play baseball, even after developing black lung in the Arizona mines. (Courtesy of Cecilia García.)

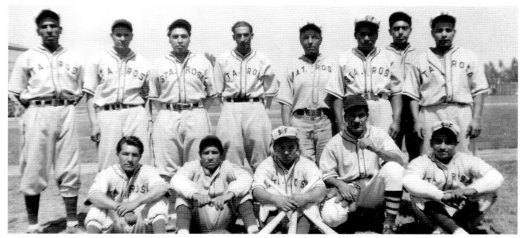

The Santa Rosa team includes Salvador Arteaga (second row, second from left) and Ray Castillo (second row, second from right). At one time, St. Ferdinand Church was the only Catholic church in the San Fernando Valley, with masses in English. Santa Rosa Church was established in 1925, allowing Spanish-speaking people to worship in their own language. Baseball was played at nearby Las Palmas Park, and it continues to be a popular sport in the parish today. (Courtesy of Cecilia García.)

The Cruz brothers played on traveling baseball teams from 1921 through 1939. Seen here are, from left to right, Francisco, Cecil, David, and Paul Cruz. In 1921, the California Fruit Growers Exchange (Sunkist) used baseball as a way to improve production and cooperation among the Mexican American employees. The employees were encouraged to become members of a local society or baseball team. The Cruz brothers learned the importance of teamwork growing up in a Catholic orphanage in Watsonville, California. (Courtesy of Pauline Cruz collection.)

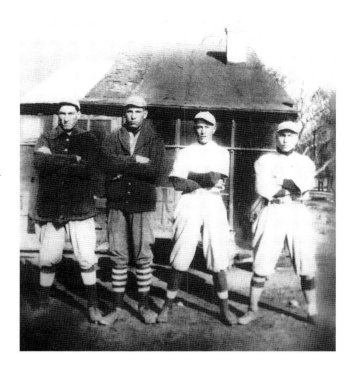

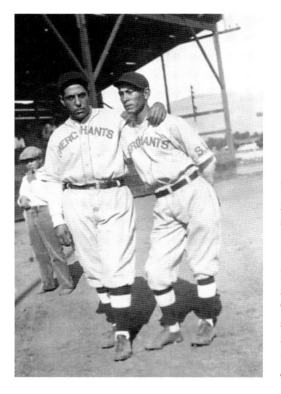

Refugio Samora (left) and David Cruz were good friends who played baseball on the same teams for many years. They served in the California State Guard in the city of San Fernando during World War II. Cruz enjoyed playing the guitar and the violin and had a great singing voice. His wife, Teresa Martínez Cruz, owned and operated a small tortilla store on San Fernando Mission Boulevard. She acquired a tortilla press and was able to produce large quantities of tortillas for distribution. (Courtesy of Alice Cruz Bacon.)

In the spring of 1919, Paul Cruz was a part-time catcher for the San Fernando baseball team. In the 1940s and early 1950s, he managed and trained pitchers targeted for the higher leagues. Cruz met Scott Drysdale (Don Drysdale's father) during spring training at San Fernando Park. Cruz became one of Don Drysdale's personal pitching trainers. Cruz's student would later become a Hall of Fame pitcher with the Los Angeles Dodgers. (Courtesy of Pauline Cruz collection.)

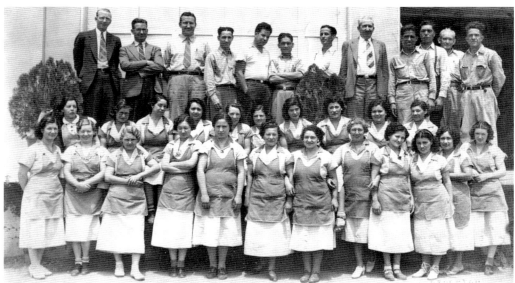

Employees of the Hazeltine Blue Goose packinghouse pose in front of the loading dock. After a long week of hard work, many people relaxed by playing or watching baseball games on Sunday. The first row includes Irene Miranda (sixth from left), Mary Ruiz (sixth from right), Mary Real Barragán (fourth from right), and Amalia Ruiz (third from right), wife of Jesus Ruiz. Rita Ruiz is in the second row, fourth from left. In the third row are Henry Real (fourth from left), brothers Jesus (fourth from right) and Ricardo Ruiz (third from right), and Arthur Lyon (far right). (Courtesy of Everto Ruiz.)

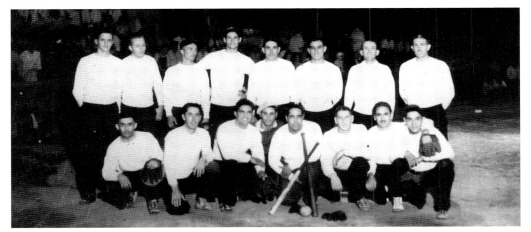

The San Fernando Athletic Association sponsored the 1932 Sunkist Lemon packinghouse team. Included in this image are Manuel A. Castro (first row, far right) and Refugio Samora (first row, fourth from right). Both Manuel and Refugio worked in the storage area and warehouse while wives Andrea P. Castro and Lucy Zamora sorted and packed lemons. It was common for husbands and wives to work at the same packinghouses. The Castros later owned and operated La Perlita Mexican Deli on the corner of Pico and Kalisher Streets. (Courtesy of Marianne Castro Lawson.)

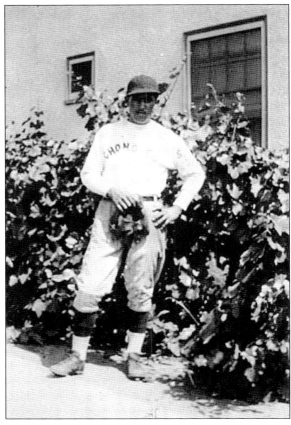

Alfonso Bórquez played on a company-sponsored team in the 1930s. He was one of 14 children of Anastacio and Delphina Bórquez, who immigrated from Mexico to Maricopa, Arizona, in 1919, where they found work picking cotton. The family traveled where work was available, sometimes sleeping on wooden crates. After moving to San Fernando, his family worked at the Sunkist packinghouse. Alfonso worked as a gardener for the Chevy Chase Country Club in Glendale for over 25 years. (Courtesy of Olivia Ruiz and Virginia Barry.)

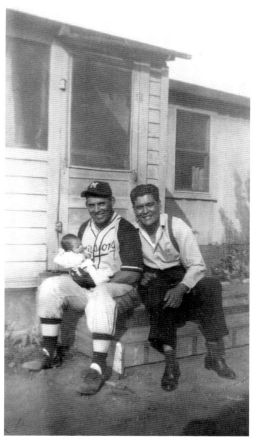

Nick Salas (left) is wearing a San Fernando Missions uniform and holding his godson next to his compadre Rubén R. Ruiz. Especially important in the Mexican American community was the strong bond formed between families. The compadre (good friend) relationship between the parents and godparents is an important bond that begins when a child is baptized and continues as the child grows up. Salas and Ruiz played on the Martínez Café softball team. (Courtesy of Everto Ruiz.)

The San Fernando Canning Company employed many residents, especially Mexican American women. Here, Jesusita Aguilar (second from the left) prepares tomatoes to be canned. Rachel Mitchell Cruz (not shown) worked at the canning company and met future husband Paul Cruz (not shown) at work in 1919. Paul was a player for the San Fernando Merchants. They were married in 1920 at the original St. Ferdinand Church. The canning company was located on the present site of St. Ferdinand School. (Courtesy of Everto Ruiz.)

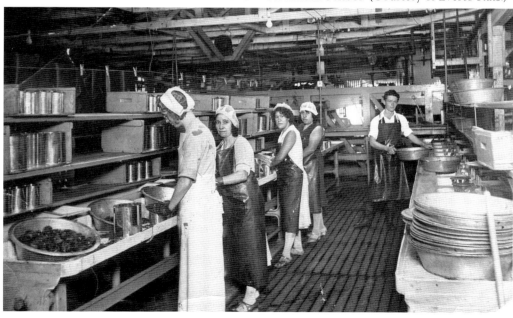

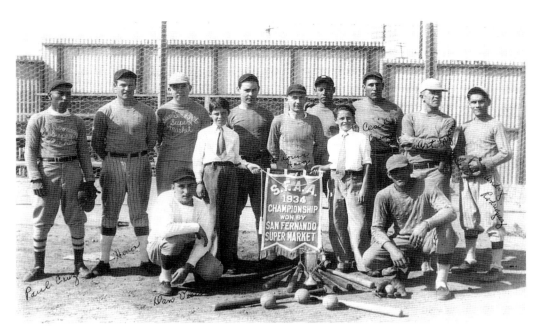

The team sponsored by the San Fernando Super Market won the 1934 San Fernando Athletic Association championship. Included in this image are Dan Velasco (first row, far left), Paul Cruz (third row, far left), Cecil Cruz (third row, third from right), Arthur Lyon (third row, second from right), and Andy Rodríguez (third row, far right). Dan Velasco, the store manager of the San Fernando market, eventually retired as the city's chief of police. (Courtesy of Pauline Cruz collection.)

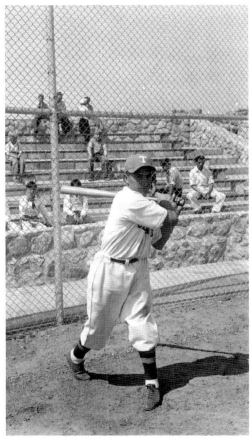

William F. Miranda played second base for San Fernando High School, the Illinois Cleaners, and the San Fernando Missions. While playing for the minor league in El Paso, Texas, Miranda was released after he told a newspaper reporter he missed home-cooked Mexican food. His grandparents Francisco and Maria Antonia Miranda homesteaded Chatsworth in the late 1800s. The 1917 movie *Jack and the Beanstalk* was filmed on the Miranda property. The Miranda Adobe still exists in the parking lot of Oakwood Memorial Park Cemetery. (Courtesy of William F. Miranda.)

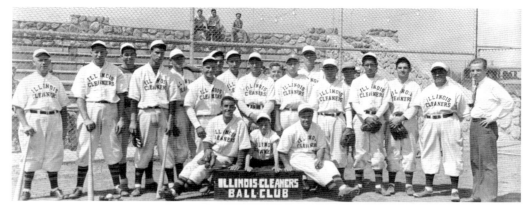

This 1938 San Fernando team, sponsored by Illinois Cleaners, includes George Vico (second row, third from left), William F. Miranda (second row, sixth from left), Alfred Hasty (second row, fourth from right), and Joaquin Sánchez (second row, third from right). Hasty went missing in action while serving on a submarine out of Pearl Harbor during World War II. He was the great-grandson of Benjamin and Anna Forrester Pico and Geromino and Catalina López, early San Fernando settlers. Brothers Cecil, Dave, Frank, and Paul Cruz helped build the stone stadium at San Fernando Park. (Courtesy of William F. Miranda.)

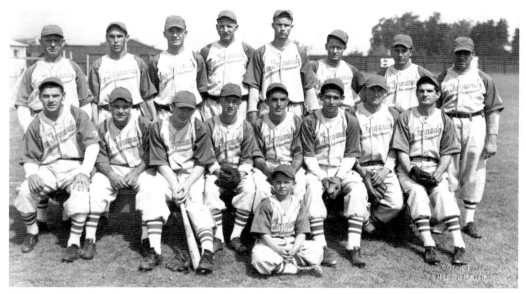

This late-1930s San Fernando High School team includes, from left to right, (first row) unidentified, Angel Emeterio, Noburo Hino, Ray Cecconi, ? Emeterio, Alfred Hasty, unidentified, and Joaquin Sánchez; (second row) unidentified, Vince Emeterio, unidentified, coach Henrichs, George Vico, unidentified, William F. Miranda, and unidentified. The batboy is unidentified. Vico later played major-league ball for the Detroit Tigers. He grew up in the Mexican American and Japanese American neighborhood in San Fernando. He was the only non–Japanese American on the San Fernando Aces. (Courtesy of William F. Miranda.)

Joaquin Sánchez, of Spanish descent, played on the San Fernando High School team, the Illinois Cleaners, and the San Fernando Merchants. A welder for United Steel in Los Angeles, he worked on the casings for the atomic bombs Little Boy and Fat Man, which were dropped on Japan in World War II. A major-league team scouted Sánchez, but his father frowned upon the idea of playing baseball for a living. (Courtesy of Gary and Carolyn Sánchez.)

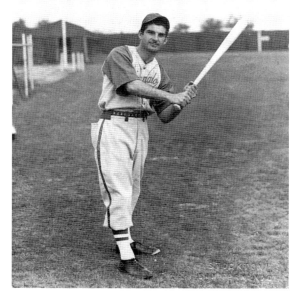

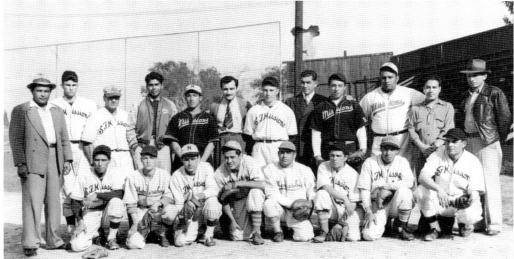

This San Fernando Missions team picture includes, from left to right, (first row) Ernie Rios, Felix Bustamante, Lupe Villanueva, Angel Guajardo, Elijio Salas, Ray Serra, Joe García, and Nick Salas; (second row) manager Arturo Magaña, George Vico, two unidentified players, Finney García, Pedro Aguilar, William F. Miranda, unidentified, John García, Marin Magaña, unidentified, and Amado "Chief" Herrera. This widely renowned team in Southern California during the 1930s and 1940s attracted dignitaries to its games, such as California governor Culbert Olson and Mexican consul Armando Rodríguez. (Courtesy of William F. Miranda.)

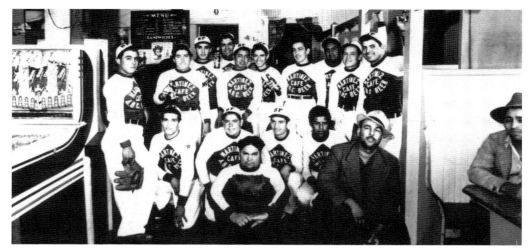

The Martínez Café softball team from the late 1930s or early 1940s includes, from left to right, (first row) two unidentified players and Ernesto Martínez; (second row) Gene Madrid Tautimes, Vince Salas, and two unidentified players; (third row) manager Francisco Carmona, Pascual Chacon, Ruben R. Ruiz, Joe García, Lupe Villanueva, Gonzalo Aragon, Marin Magaña, Cipriano Alba, and Nick Salas. Ernesto Martínez sponsored numerous softball teams through his bar and restaurant, Martínez Café, located on San Fernando Mission Boulevard and Kewen Street. The 1948 team won the Mexican Athletic Union softball championship. (Courtesy of John Martínez.)

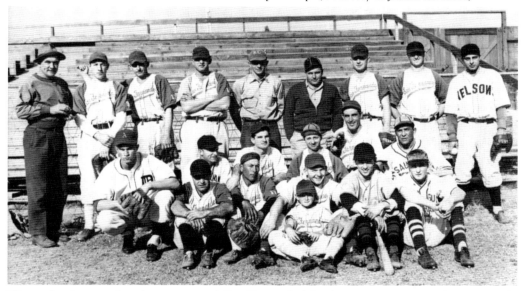

The multiethnic and multigenerational San Fernando Merchants team poses at San Fernando Park in the 1940s. Among those pictured here are George Vico (front row, squatting at left in Detroit Tigers jersey), Angel Emeterio (first row, second from left), Paul Cruz (first row, third from left), hard-hitting Joaquin Sánchez (second row, second from left), and Scott Drysdale (third row, second from right), the father of Don Drysdale. Cruz was a well-respected veteran player. (Courtesy of San Fernando Valley Historical Society.)

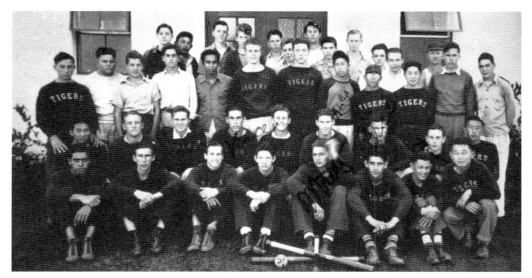

The 1940 San Fernando High School varsity baseball team was very integrated, with Mexican American and Japanese American members. The team included Ray Castillo, Alex Vaíz, Vince Emeterio, Natividad Estrada, Alfred Hasty, George Vico, Burt Russell, Bill Lardner, Noburo Hino, George Endo, Mas Nakadaira, and Yas Matsuda. The Japanese Americans were a part of the barrio, living and working with Mexican Americans and, in many cases, speaking Spanish. From the school grounds to the neighborhood, baseball provided an equal playing field for all. (Courtesy of Alice Lyon Carrillo.)

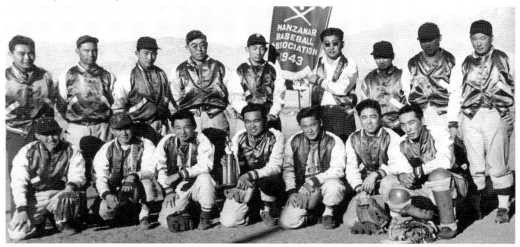

The San Fernando Aces were the 1943 baseball champions at Manzanar, which was one of 10 camps where Japanese American citizens were interned during World War II. The Aces were comprised of Japanese American players from the city of San Fernando, all lettermen from San Fernando High School. Identified players here are Hiro Hino (first row, third from right), brothers Berry Tamura (first row, far right) and George Tamura (second row, third from left), team captain Pete Mutsui (second row, fourth from left), and Jim Tamura (second row, fifth from left). (Courtesy of George and Miyeko Tamura.)

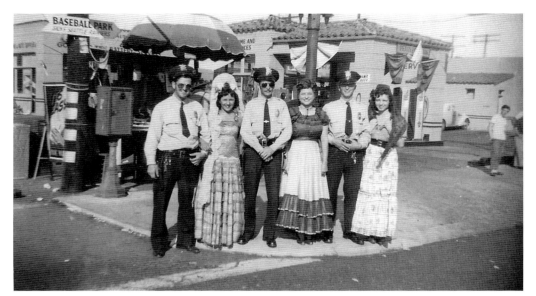

The annual San Fernando Fiesta was held to celebrate San Fernando's rich Mexican heritage stemming from the mission days. Many of the residents dressed in costume and participated in the related social activities. The women shown here are, from left to right, cousins Alice Lyon, Emma Mula, and Mary Jo Henderson (Miss San Fernando 1949). The San Fernando police officers are not identified. The sign at the upper left points out the direction to the San Fernando Baseball Park, where the Seattle Rainiers held spring training. (Courtesy of Mary Jo Moss.)

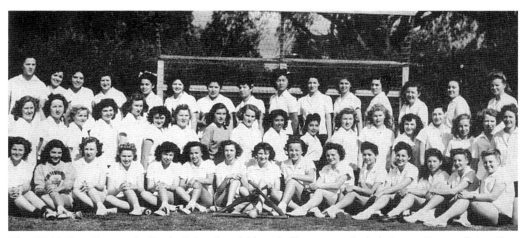

The 1946 San Fernando High School girls' baseball team included Angie Sierra (Miss San Fernando 1947), Natividad Arteaga, Priscilla Real, Tillie García, Esparanza García, Vera López, Rosie Roma, Dora Ramírez, Armida Cordova, Josie Reyes, and Rosalie Estandia. Real (first row, sixth from left) pitched on the varsity team as a freshman. She continued to play after high school, until she married. Her husband, Gabriel Muñoz, told her that a married woman should not be playing. (Courtesy of San Fernando High School.)

Paz Puga (inside car), Alice Guerrero (center), and Chris Díaz were members of the San Fernando Blue Jays softball team. The team practiced and played at Las Palmas Park and became the league champions of the Valley in 1948. These women attended San Fernando High School and worked at a poultry plant in Sun Valley. The advent of the automobile allowed women to become more independent and assertive. (Courtesy of Karole Obrikat.)

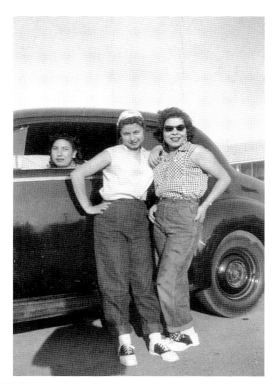

Pete Acebo was employed by the San Fernando Recreation Department in 1945, when he accepted management of the semipro Missions team from Art Magaña. At that time, the team played ball at Mott and Kalisher Streets, on the current site of the Santa Rosa school. The team was once known as the San Fernando Merchants. Acebo coached and trained many hopefuls and was credited with the club's development of professional players. (Courtesy of Marie Acebo.)

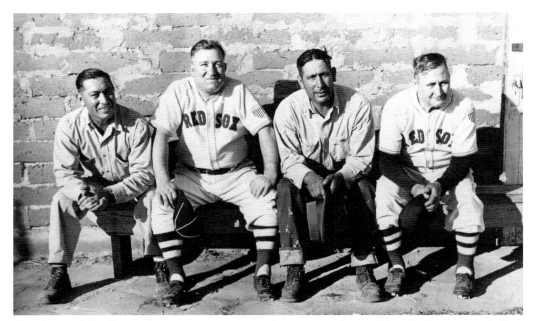

San Fernando Park was the spring-training site for many professional baseball teams, including the Seattle Rainiers and Oakland Oaks in the 1940s. City employees David Cruz (far left) and brother Cecil Cruz (second from right) are seen taking a break with Red Sox training managers. The Cruz brothers played on the San Fernando Athletic Association baseball team. Casey Stengel was at the helm of the Oaks' new San Fernando training camp and clubhouse. Trainer Jesse "Red" Adams worked over the sore muscles of the athletes. (Courtesy of Alice Cruz Bacon.)

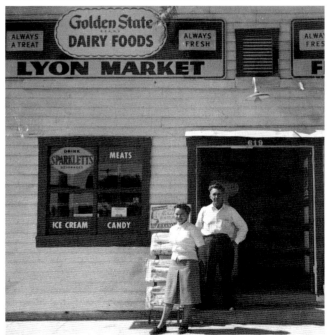

Edward D. Lyon and daughter Alice stand in front of Lyon Market on San Fernando Mission Boulevard in 1949. Edward and his wife, Victoria Real, owned and operated the neighborhood market and extended credit to many customers. Small markets (*tienditas*) were vital to the livelihood of struggling families trying to cover their needs in difficult times. Doña Victoria was well respected and known for her graciousness. Edward sponsored many local groups and organizations, including sports teams. (Courtesy of the Carrillo/Lyon family.)

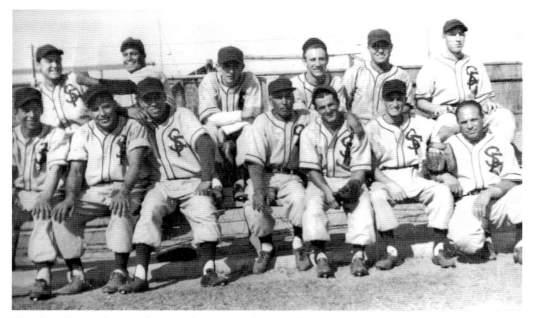

The San Fernando Merchants take a relaxed team photograph at San Fernando Park in 1951. Shown here are, from left to right, (first row) John Fonseca, Jess Franco, Bob Hernández, Paul Cruz, and three unidentified players; (second row) Eddie Sierra, Ritchie Ortíz, Bruce Erickson, unidentified, Ernie Ortíz, and unidentified. Sierra's parents, Edward and Arsenia, were the original owners of Ed Sierra's Spanish Café in San Fernando. Later, son-in-law Gil Jaramillo bought the business, changing the menu and renaming the establishment Sierra's Mexican Restaurant. (Courtesy of John Fonseca and Lorrie Carrillo.)

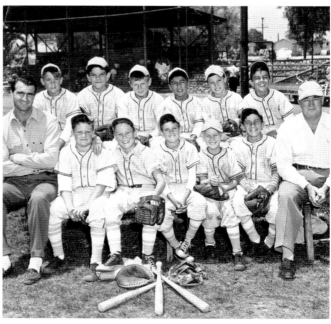

The 1951 San Fernando White Sox Little League team picture includes, from left to right, (first row) coach Ralph ?, Jimmy Jack, Perry ?, Jimmy?, ? Smith, Frank Feese, and coach Bryan Cone; (second row) Don Brown, Ralph Contreras, unidentified, Pinney García Jr., Oscar Ortíz, and Nick Emeterio. Cone sponsored the team and owned the Regal Pale Brewery on Truman Street. This was the first year that hardball was played on a softball diamond at San Fernando Park. (Courtesy of Pinney García Jr.)

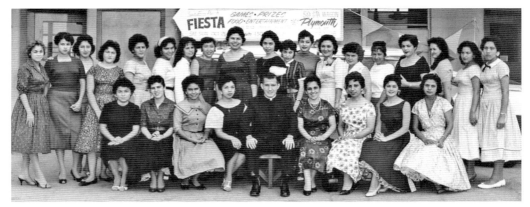

The Santa Rosa Senorita Club was a social organization that enabled single women to have a social life outside of the home. The group sponsored dances, allowing woman to meet single men from the neighborhood parish. Pictured with the group in 1959 is Father Amador López. Many of the young ladies in the club had brothers, fathers, or uncles who played baseball. The family surnames in the barrio that continue to be well-known to this day include Arteaga, Gil, Gonzáles, Naranjo, and Pacheco. (Courtesy of Cecilia García.)

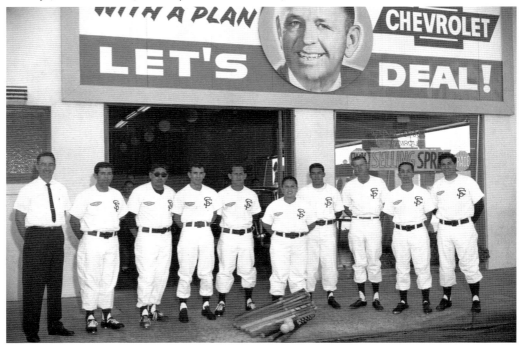

Tom Carrell Chevrolet sponsored this 1960s team. Carrell owned the car dealership on San Fernando Road for many years. It was located near the site of the San Fernando Fruit Growers Association packinghouse. Shown here are, from left to right, Cliff ?, Ruben L. Ruiz, Mickey Valdez, Ernie Castro, Tony Márquez, unidentified, Ray Barraza, unidentified, Tony Flores, and manager Andy Durazo. Barraza was considered the best fast-pitch softball pitcher in the San Fernando Valley in the 1950s. (Courtesy of Everto Ruiz.)

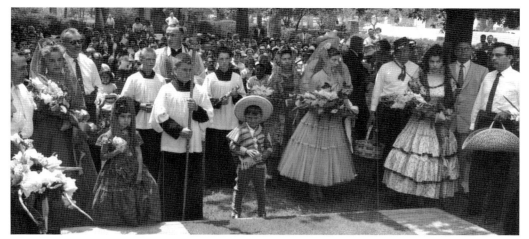

The Blessing of the Fruit and Flowers ceremony was held at Brand Park next to the San Fernando Mission. This ceremony initiated the annual San Fernando Fiesta. The fiesta theme was rich in tradition and heritage, recapturing early California and mission days. The entire community was involved. Events included a parade, a Mantilla Banquet, and the coronation of a fiesta queen. The young boy dressed in costume is Albert J. Carrillo. He played baseball at San Fernando Recreation Park in the 1960s. (Courtesy of Victoria C. Norton.)

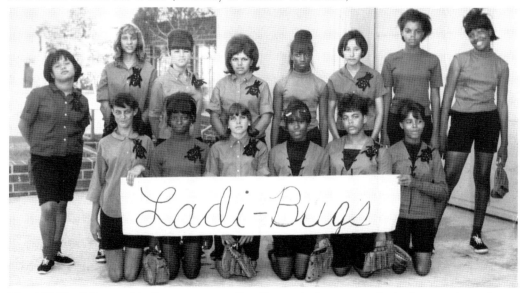

The 1966 Ladi-Bugs softball team poses at San Fernando Recreation Park. Among those shown here are cousins Arlene Bailey (second row, second from left) and Sandra Frias (second row, third from left). Bailey's sister Lorrie López played on the Paragon's team, sponsored by the CYO (Catholic Youth Organization) at Santa Rosa Church. Many of the girls on the Ladi-Bugs team were African American. Many African American families that moved to the Valley were relegated to Pacoima because of housing restrictions for people of color before the 1960s. (Courtesy of Sandra Savala.)

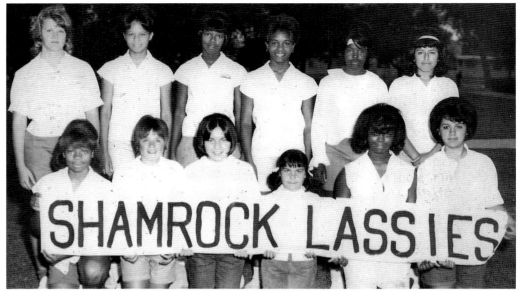

The Shamrock Lassies were the 1965 San Fernando Ponytail League champions. Shown here are, from left to right, (first row) Brenda White, Kathie Tapp, Christine "Pinki" Puga (pitcher), sister Karole Puga (batgirl), Vickey Holmes, and Joanne Cruz; (second row) Charlotte Finch, Sharon Emory, Linda Armstead, Rosalyn Emory, Jackie Hill, and Patsy Rodríguez. The Pugas' father, Pete, coached the team, and their mother, Chris, was team mother. Brother Ronnie Puga also played youth baseball. (Courtesy of Christine "Pinki" Puga and Karole Obrikat.)

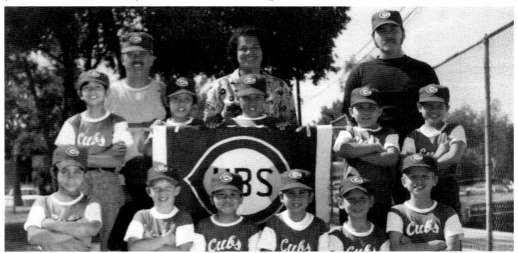

The 1972 San Fernando Cubs team includes Augustine Reyes (second row, second from right). Typical and important for the team's success were the team mother and coaches, who were often fathers or older brothers. Reyes's grandfather Salvador Arteaga played on the Santa Rosa men's team. His mother, Natividad Arteaga, played on the San Fernando High School girls' varsity team. His aunt Cecilia Arteaga played on the Santa Rosa girls' team, and aunt Carmen Arteaga played on the Blue Jays women's team. Brother Anthony also played ball. (Courtesy of Cecilia García.)

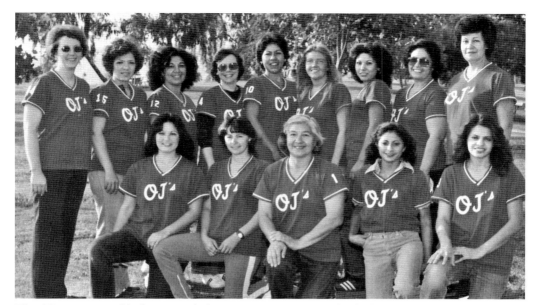

The OJ's women's softball team includes Epimenia "Pepper" Delgado (first row, center) and daughter Mary Helen Delgado (second row, center). Pepper was an inspirational role model. After raising 12 children, she found enjoyment playing softball. In her senior years, she loved to entertain people by singing and dancing. Another role model, Virginia Barragán (second row, far right), played softball for over 35 years, 3 years at the semipro level. In 1953, she was the first Mexican American woman to work in an administrative position at Lockheed. (Courtesy of Rita Delgado.)

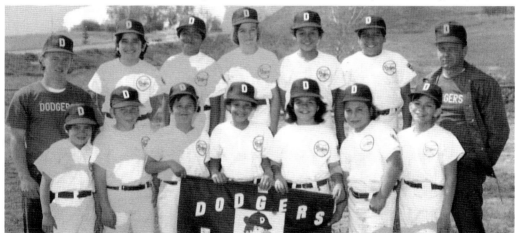

The undefeated 1972 Dodgers Little League team includes David Gonzáles (first row, far left), and pitchers Jimmy Espinosa (first row, third from right) and Danny Flores (first row, second from right). David, a left-handed second baseman, played on the Babe Ruth all-stars. He coached and officially umpired at Santa Rosa Baseball Little League, and son Robert Gonzáles (current city of San Fernando mayor pro tem) played on the Santa Rosa Bronco Blue Jays. David was a licensed umpire for the Valley Region men's and women's softball league. (Courtesy of the Gonzáles family.)

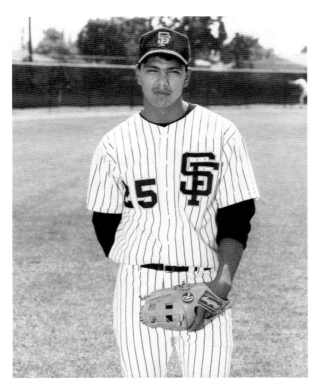

Rick Savala represents four generations of baseball players in one family. The San Fernando High School pitcher followed in the steps of his great-uncle John Fonseca, who pitched 40 years prior. Rick's mother, Sandra Frias, played on the 1966 girls' softball team, the Ladi-Bugs. His grandmother Ramona Fonseca played on the 1943 San Fernando Rotary women's team. His great-great-uncle Albert García played on the 1909 San Fernando team. (Courtesy of Sandra Frias Savala.)

Paul Cruz, shown here in 1950, was known as an outstanding ballplayer in the Los Angeles area. Paul and his three brothers played for numerous Athletic Association baseball teams that traveled throughout Southern California's Mexican American league for over 30 years. Brothers Paul, Francisco "Chico," Cecil, and David Cruz all worked for and retired from the City of San Fernando. Their retirement signaled the end of their long baseball careers. (Courtesy of Pauline Cruz collection.)

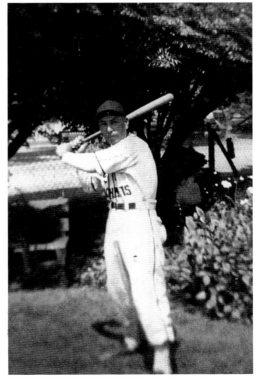

2

THE SAN FERNANDO VALLEY

In the decades following the founding of San Fernando in 1874, real estate companies divided the nearby land into several towns. The surrounding Valley grew in spurts, fueled by the extension of the railroad, the Owens Valley aqueduct, and the emergence of large-scale agricultural production.

Although the foundation of the Mexican American population resided in San Fernando, many arriving migrants settled in neighboring Pacoima, making the northeast Valley a significant Mexican enclave. Before the 1950s, other barrios existed in North Hollywood, Van Nuys, Burbank, Glendale, Chatsworth, and Canoga Park, while a few Mexican families lived in Reseda and Sunland-Tujunga. These towns all featured men's, women's, and youth clubs that were the spotlight of the community on Sundays.

The Valley included a variety of baseball and softball teams that reflected local community history. The talented Pacoima Athletics, formed after World War II, consisted of married veterans who played every Sunday in front of their families at Pacoima Park, while the North Hollywood Orcasitas softball teams included players of all ages, who constructed their own diamond out of a vacant sandlot in the barrio. The 1930s Chatsworth team was comprised of ranch hands who worked in the thriving San Fernando Valley citrus industry in the early 20th century. The Van Nuys General Motors United Auto Workers softball teams of the 1960s were an important source of camaraderie and relaxation for Mexican American autoworkers. The Burbank Holy Trinity teams reveal the close relationship between the Burbank Mexican American community and St. Robert Bellarmine Church. In Reseda and Sunland-Tujunga, Mexican Americans managed and played on predominately white teams, while Pacoima and Lake View Terrace featured multiethnic black and Mexican American clubs. Like their male counterparts, women's teams, such as the Burbank B Bops, North Hollywood Vixies, North Hollywood Huskies, and Van Nuys Texas Grocery, went on weekend excursions, traveling on flatbed trucks to different towns and forming valuable friendships and networks. By the 1960s, several Mexican American players from the Valley had broken into professional baseball, playing in the major leagues, minor leagues, and for scout teams.

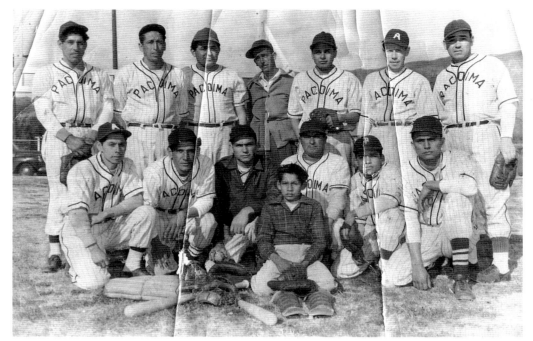

The late-1940s Pacoima Athletics baseball team includes, from left to right, (first row) George Villanueva, unidentified, Pete Prieto, Raymond Pacheco, Poncho Torres, and Eddie Prieto; (second row) Nacho Calzada, Simón Salas, Angel Luna, unidentified, Poncho Torres, Del Rey, Ted Villanueva, and unidentified. Seated in front is batboy Alfred J. Calzada. The Athletics lasted until the early 1950s. Slugging first baseman Eddie Prieto won municipal league home-run awards and once hit a homer off young Don Drysdale. Younger brother Pete Prieto starred as the pitching ace. (Courtesy of Pete Prieto.)

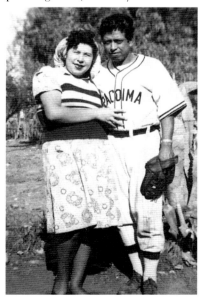

Myra Lomeli Hernández stands next to her husband, Lupe G. Hernández, a Pacoima Athletics player, in 1947. Her family remembers that Myra loved watching Lupe play baseball. Many of her weekends were spent at the ballpark, taking care of her five children as she cheered him on. In her later years, she continued to be a spectator at baseball events, watching her own children and grandchildren carry on the tradition as ballplayers. (Courtesy of Terry Hernández and Rita Hernández Ontiveros.)

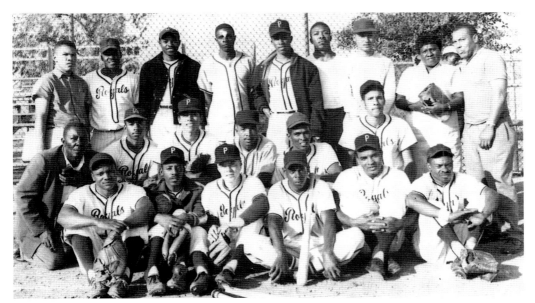

The multiethnic 1958 Pacoima Royals features Danny Guzmán (second row, third from left). Younger brother Moses (not pictured) served as batboy. Other brothers David, Bengie, Tommy, and Ishmael played for decades in various baseball and softball leagues, and all six played for San Fernando High School. Around World War II, African Americans increasingly moved to the San Fernando Valley. Until the 1960s, they were restricted to the area around Pacoima, living in the Basilone veterans homes or the all–African American Joe Louis housing tract. (Courtesy of Moses Guzmán.)

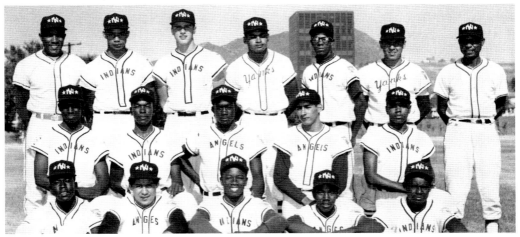

The 1965 Lake View Terrace Pony League all-star team includes future major-leaguer Gary Matthews (first row, far left), George Polo (first row, second from left), and Bob J. Calzada (second row, second from right). Calzada tried out with the Dodgers in 1967 after receiving a letter of interest from scouting director Al Campanis. His father, Nacho, played for the Pacoima Athletics in the 1940s, and his twin grandsons, Ryan and Jovan Camacho, continue the family baseball legacy today, ranked among the top youth players in the Valley. (Courtesy of Bob J. Calzada.)

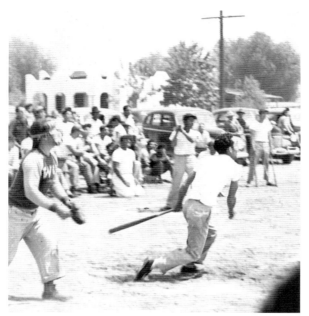

Tony Servera hits a long drive at the Orcasitas barrio field in 1946. Servera constructed the field from a vacant lot on the corner of Stagg Street and Irvine Avenue in North Hollywood. Every Saturday, he watered and dragged the field in preparation for Sunday games. A lifelong resident of North Hollywood, Servera fought in the invasion of Okinawa during World War II. After the war, he bought one lot in the barrio and founded the family construction company, which his grandson currently manages. (Courtesy of Tony Servera.)

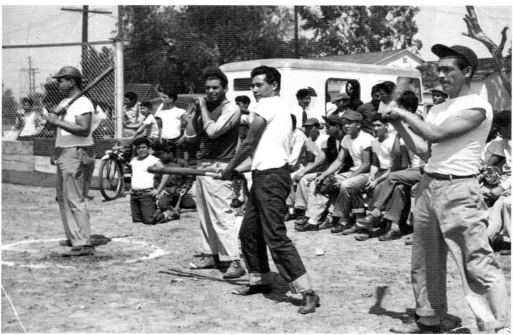

Standing in the Orcasitas ball field are, from left to right, Mark Montoya, Al Márquez, Vince Sánchez, and Mike Alderete. Described as "a little Mexican village" within North Hollywood, the Orcasitas barrio had no paved streets, electricity, or running water into the 1940s. The neighborhood was named after Fernando Horcasitas, the man who owned the 100 lots in the five-street neighborhood. Migrating Mexican American families in the 1920s and 1930s bought the lots on credit and would build their own small homes. (Courtesy of Speedy Gonzáles.)

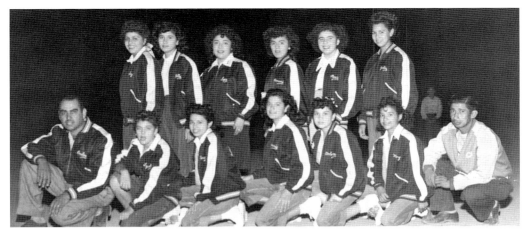

The North Hollywood Vixies team poses in 1949. Shown here are, from left to right, (first row) manager Carlos Lugo, Lydia Sánchez, Teresa Hernández, Connie Lugo, Dolores Moreno, Mary Hernández, and manager Chelo Ramírez; (second row) Lucy Castillo, Stella Quijada, Lupe Castillo, Ramona Valenzuela, Rosie Chávez, and Julia Salazar. The Vixies played teams from all areas of the Valley, such as the San Fernando Blue Jays, Burbank B Bops, North Hollywood Huskies, and Pacoima Honeydrippers. (Courtesy of Connie Lugo Ferrer.)

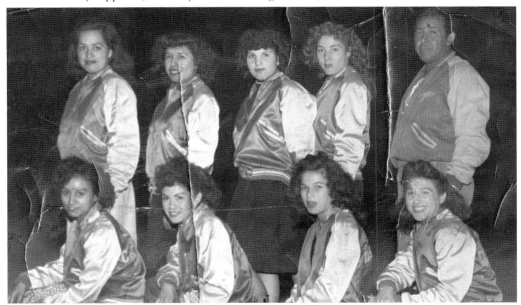

The late-1940s North Hollywood Huskies women's community team picture features, from left to right, (first row) Flora Hernández, Beta Sánchez, Becky Montenegro, and Lupe Montenegro; (second row) Carmen Pompo, Annie Reyes, Minnie Moreno, Dora Ybarra, and coach Inéz Reyes. The Huskies originated in the Orcasitas barrio and played before hundreds of spectators, who ringed their cars around the outfield. The players wore kelly green jerseys and pedal pushers. Outstanding catcher Moreno also played on a women's hardball all-star team. (Courtesy of Minnie Moreno.)

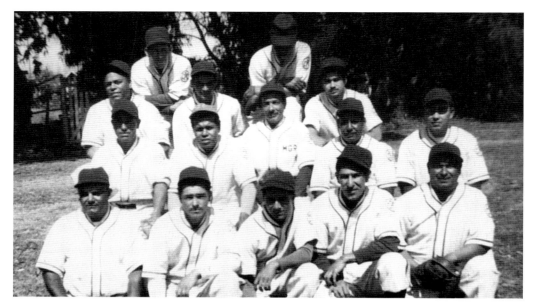

This Orcasitas barrio team of North Hollywood includes players Joffee García (first row, far left), Mike Alderete (first row, second from left), and Ernie Gonzáles (first row, second from right). Gonzáles served in World War II as a staff sergeant in the Army infantry in Luzon, Philippines, and stayed on duty in Japan after the dropping of the atomic bombs. He was awarded several medals, including the Silver Star. (Courtesy of Speedy Gonzáles.)

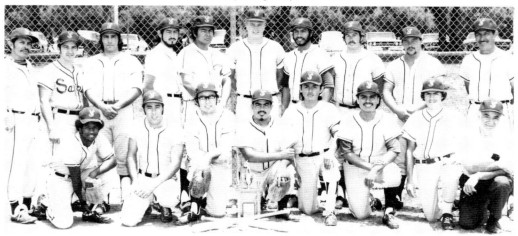

Members of the 1977 Valley Saints display their municipal league trophy. Seen here are, from left to right (first row) four unidentified players, Manuel Cervantes, Joey Cervantes, Louie Cervantes, and unidentified; (second row) Joseph Cervantes, Carlos Gonzáles, Steve Gonzáles, Speedy Gonzáles, two unidentified players, Paul Govea, Frank Gonzáles, unidentified, and Ernie Gonzáles. Joseph Cervantes won manager of the year. His wife, Ramona, played at North Hollywood High School and for the North Hollywood Vixies in the 1940s. Their great-grandson Ryan Cruz was drafted by the San Francisco Giants in 2014 and currently pitches for Long Beach State. (Courtesy of Ramona Valenzuela Cervantes.)

In 1956, Marty Cortinas played on the North Hollywood High School junior varsity baseball team. Born in 1940 in Bakersfield, Cortinas moved to the Valley in 1950. His family lived in Sun Valley, located just north of North Hollywood. In his senior year, 1958, the third baseman received All Valley awards as a leadoff hitter and fast runner for the varsity squad. After high school, Cortinas played for Pierce College in Woodland Hills in 1959 and 1960. (Courtesy of Marty Cortinas.)

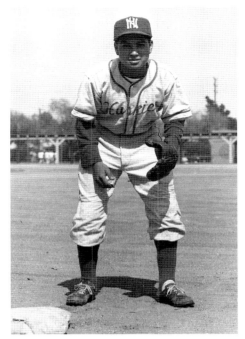

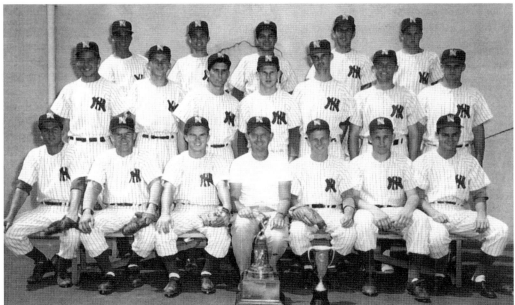

In 1957, North Hollywood High became the first Valley team to win the annual Los Angeles City Dorsey Baseball Tournament, beating Washington High for the championship. Speedster and hard-throwing infielder Marty Cortinas (third row, third from left) was called up in the second half of the season from junior varsity and played in the tournament. Other players include Carlos Royval (third row, second from right) and future major leaguer Ronnie Brand (first row, third from left.) (Courtesy of Marty Cortinas.)

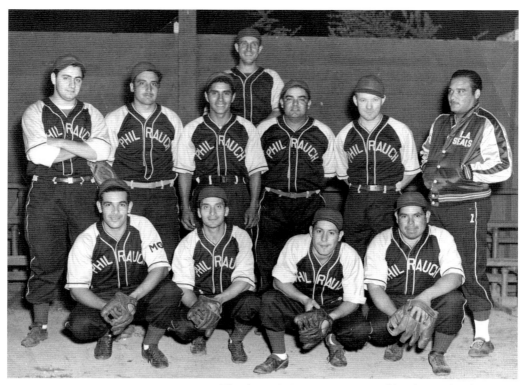

This late-1940s team, sponsored by the Burbank Phil Rauch Studebaker dealership, includes, from left to right, (first row) Gene Madrid Tautimes, unidentified, Bill Alba, and Vince Salas; (second row) unidentified, Ángel Rodríguez, John De La Cerda, Joffee García, and two unidentified players. Tautimes is remembered as a loving, supportive father and role model to many young men in Burbank. An outstanding football player out of Burbank High School, he was later stationed in Virginia during World War II. (Courtesy of Mary Jane Muro.)

Gene Madrid Tautimes was one of the most athletic baseball and softball players in Burbank from the 1930s to the 1950s. Born in 1916 in Benson, Arizona, he was a prized power hitter who played for several teams at any given time in the Valley. His skills were often praised in the local Burbank newspaper. One cartoon sketch features the caption: "I don't care if it is softball! If you ever tried to field one of Gene Madrid's line smashes you'd know why I'm wearing this outfit!" (Courtesy of Mary Jane Muro.)

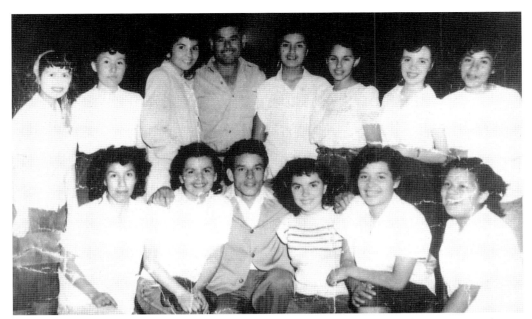

The Burbank B Bops of the late 1940s include, from left to right, (first row) Eleanor Yánez, Eleanor Roblero, Rudy ?, Tencha Moreno, Marie Alvarado, and Lupe Díaz; (second row) Rosie Díaz, Margaret Escudero, Lobbie Trejo, Henry Alvarado (coach), Ramona Sarmiento, Judy Dávila, Margaret Moreno, and Ruth Silvas. The B Bops were close friends at Burbank High School and lived in the barrio around Flower Street and Verdugo Avenue. In Burbank, Mexican Americans could not buy land above Glenoaks Boulevard and were not allowed in some theaters and recreational facilities. (Courtesy of Rosie Díaz.)

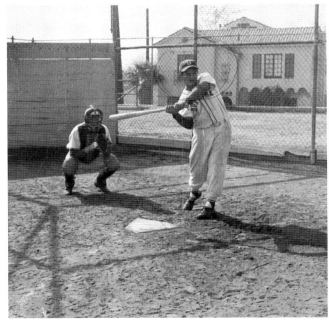

Joe Fernández demonstrates his swing during practice. In 1961, he won all-league awards, batting .452 for the Burbank High Bulldogs. The senior left fielder also won the most valuable player award as the lone Mexican American on the team. After high school, the Dodgers invited Fernández to try out, but he chose instead to focus on starting a family with his high school sweetheart, Vernie Jeanne. The couple has been married for over 50 years and counting. (Courtesy of Julie Fernández and Joe Fernández.)

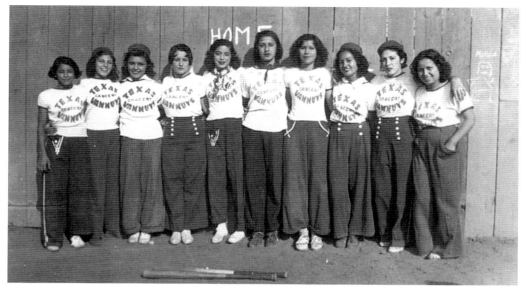

Members of the 1937 Van Nuys Texas Grocery team are, from left to right, Lillian Ruiz, Dora Martínez, unidentified, Alice Ruiz, Virginia Ruiz, Lillian Guardia, Atelvina Vásquez, unidentified, Beatrice Ruiz, and unidentified. The team played on a makeshift ball field at Delano Street and Cedros Avenue. Team sponsor Texas Grocery was a local market owned by a Japanese American family. The Ruiz sisters were descended from one of the early Mexican Californian families who at one time owned extensive land in Los Angeles. (Courtesy of Virginia Ruiz Durazo and Jackie Durazo Murphy.)

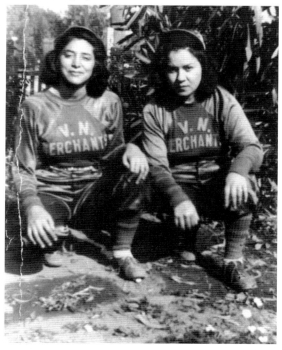

Virginia Ruiz Durazo (left) and her sister-in-law Connie Ruiz don their husbands' Van Nuys Merchants uniforms in the early 1940s. Virginia's family moved into the fourth house built in Van Nuys, where her father worked for Van Nuys Brick & Tile. She remembers the small-town feeling of Van Nuys, which included walnut and apricot orchards. Virginia met her husband, Ralph Durazo, a baseball player from San Fernando, while playing softball. (Courtesy of Virginia Ruiz Durazo and Jackie Durazo Murphy.)

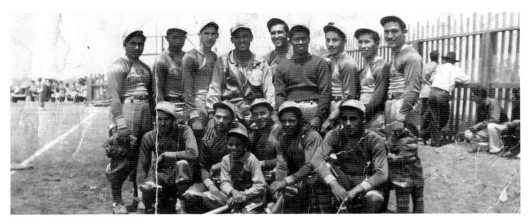

The early-1940s Van Nuys Merchants gather at their home ball field, located next to the brickyard. Shown here are, from left to right, (first row) Julián Barraza, Mike Pacheco, batboy Danny Pacheco, unidentified, Joe Ybarra, and Joe Gutiérrez; (second row) Mike Palacio, Joe ?, Ralph Durazo, Angel Guajardo, Tommy Ruiz, Louie Gonzáles, Rupert Pacheco, unidentified, and Frank Ruiz. Skilled catcher Durazo also played on the famed San Fernando Missions. In World War II, he fought with the 25th Infantry Division in Luzon, Philippines. (Courtesy of Virginia Ruiz Durazo and Theresa Tresierras Durazo.)

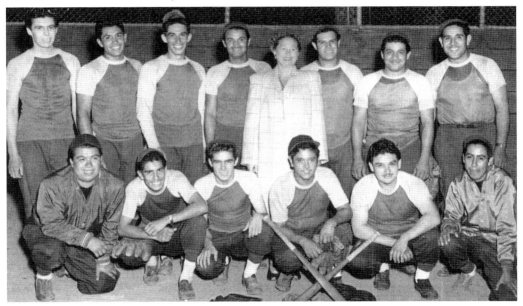

The 1940s Van Nuys Alyce Blue Gown softball team picture includes, from left to right, (first row) Louie Gonzáles, Joe Ramírez, Rubén Díaz, Joe Ybarra, Manuel Barraza, and Willie Abundes; (second row) Art López, Arnold Fernández, Gilbert Pedraza, Art Ramos, unidentified woman, Bill López, Bengie Gutierrez, and Steve Ramírez. Alyce Blue Gown, the team sponsor, was a popular bar in Van Nuys. Gonzáles and Abundes were top-notch players at Van Nuys High School. Gonzáles received scholarship offers to play in college, but he decided to stay at home to work and help support his family. (Courtesy of Gloria Gonzáles.)

"I used to get up in the morning with a glove in my hand" remembers Ray Barraza. Van Nuys native Barraza played on several fast-pitch softball teams and participated in many tournaments, even traveling to Oklahoma. He recalls playing against Don Drysdale on the Van Nuys High School baseball fields after school. Barraza won MVP and strikeout king awards as a softball pitcher in the 1950s and was even approached by a scout from the Chicago White Sox. (Courtesy of Ray Barraza.)

The 1950 Van Nuys Blue Streaks team includes, from left to right, (first row) Ray Barraza, unidentified, and Tom Ruiz Jr.; (second row) four unidentified players and Manuel Ponce. Players lived in the Van Nuys barrio, and the team typically played in the neighborhood; but, on occasion, it crossed the boundary of the barrio to play at Vanowen Park. Barraza remembers the hostility this caused, as cops chased him and his friends away for being on the wrong side of Van Nuys Boulevard. (Courtesy of Virginia Ruiz Durazo and Jackie Durazo Murphy.)

The late-1940s Burbank St. Robert Bellarmine Church "Holy Trinity" team picture shows, from left to right, (first row) Ray Carbajal, Dick Santoyo, Arthur Yánez, Mock Santillán, and Joe Armendáriz; (second row) Joe Lara, Viviano García, Gene Vehing (coach), Eddie Ávila, Bob Díaz, Tony Gonzáles, and Bob Escudero. Players typically had older brothers and cousins who played on previous St. Robert Bellarmine teams in the 1930s, such as in the Santoyo and Lara families. Most of these players would serve in the Korean War. (Courtesy of Alex Sáenz.)

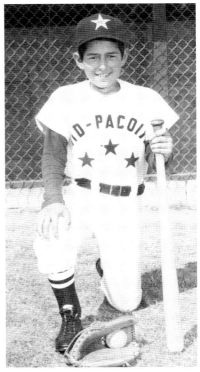

Speedy Gonzáles was a key player on the 1965 sectional champion Pacoima Little League all-star team. Gonzáles lettered in baseball at Poly High School in Sun Valley and played on the competitive Valley Saints municipal league team. He earned a spot on a Baltimore Orioles scout team, where he impressed by striking out nine batters in one game. His brother Steve received offers from the San Francisco Giants and Chicago Cubs after hitting .500 and helping the Saints win two championships. (Courtesy of Speedy Gonzáles.)

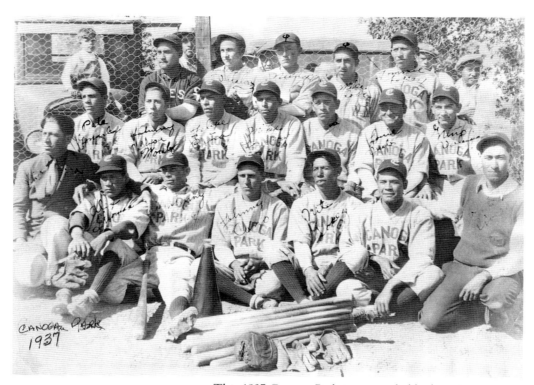

This 1937 Canoga Park team was led by longtime manager Severiano "Babe" Valencia (second row, far right). Among the players are Johnny Cano (first row, fourth from left), Che Miranda (first row, second from right), and Pete Gonzáles (second row, far left). The team played on a vacant lot at the corner of Deering Avenue and Gault Street. The Canoga Park barrio formed in the 1910s, after the American Sugar Beet Company constructed eight adobe homes for pickers along Hart Street. (Courtesy of Armando Valencia.)

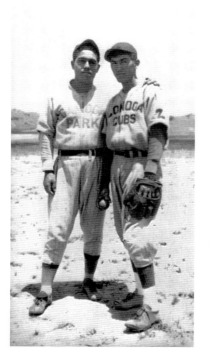

Severiano "Babe" Valencia (right) emerged as one of the foremost baseball figures in the west San Fernando Valley throughout the 1930s and 1940s. He managed highly successful mixed Mexican American and white Canoga Park municipal league teams and secured financial support from local business owners. His leadership was often reported in the *Van Nuys News*, as manager of the Canoga Park Merchants and Babe Valencia's All-Stars. Valencia later umpired on weekends for decades and managed his children's teams. (Courtesy of Richard F. Encinas.)

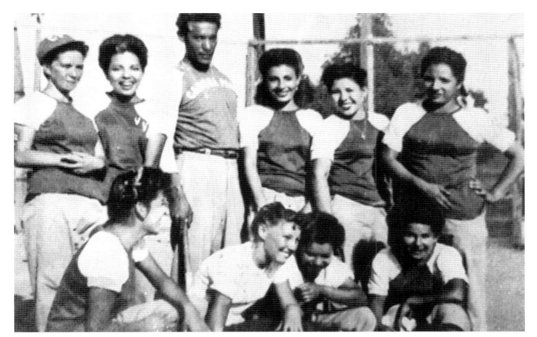

This early-1940s Canoga Park women's team photograph includes, from left to right, (first row) Dora Villanueva, unidentified, Ueva Simón, and Lupe Trujillo Hernández; (second row) Mary Córdova Signis, Evangelina Villanueva Olivas, manager Ángel Pérez, Sophie Roldán, Alice Puentes Minjares, and Tina Oros. A lifelong native of Canoga Park, Pérez sponsored a male softball team from 1966 to 1970 through his restaurant, Lichas Mexican Food. He also worked as business representative for the local 300 laborers' union. (Courtesy of Margaret Pérez Amescua.)

Ritchie Encinas kneels with his son Richard and daughter Armida. Encinas established himself as an outstanding shortstop and captain for the predominately white Reseda Merchants and also played for Canoga Park teams. His exploits were widely covered in Valley newspapers, and he received attention from professional baseball scouts. He was denied a contract because of his Mexican American background. Encinas moved from Arizona to the small town of Reseda in his Model T around 1930, becoming one of the first Mexican American residents in the sparsely settled area. (Courtesy of Armida Encinas.)

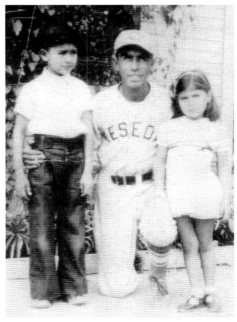

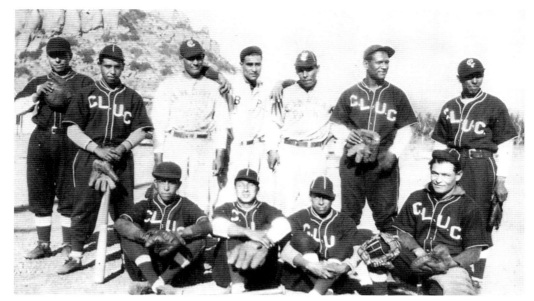

In 1930, members of the Chatsworth team (black uniforms) have lined up alongside Canoga Park players (white uniforms) in front of Stoney Point in Chatsworth. Players include José Castañeda (first row, second from left) and José Jiménez (second row, far left with first baseman's mitt). The Chatsworth team played throughout the Valley and traveled to Los Angeles, Bakersfield, and Fresno. It also competed against visiting Mexican clubs from Tijuana. Most players, such as Castañeda and Jiménez, worked on the citrus ranches around Chatsworth. (Courtesy of Rachel Jiménez and Art Castañeda.)

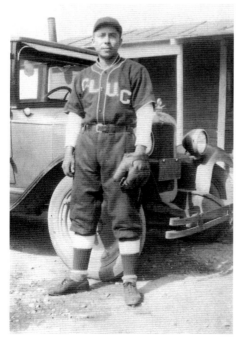

José Jiménez was born in 1908 in San Fernando, Durango, Mexico. He came to Chatsworth with his family from Arizona in the 1920s and worked in construction and in the citrus orchards. He lived in the colonia of Chatsworth, located on Chatsworth Street between Variel and Independence Avenues. Jose and his wife, Juana, later raised six children in nearby Canoga Park, where he was active in the Apostolic Church in the Faith of Jesus Christ. (Courtesy of Rachel Jiménez.)

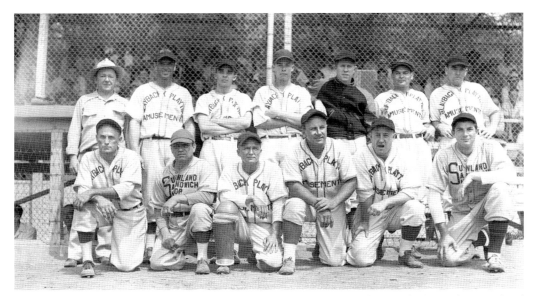

The Sunland-Tujunga Merchants of the 1940s and 1950s frequently drew packed crowds at Sunland Park. Frank Pérez is seen in the first row, third from left. Born in Phoenix in 1912, Pérez moved to California at the age of seven. A hard-throwing submarine pitcher, he played one year in the Chicago Cubs farm system. His son George played one season for the Pittsburgh Pirates. Frank Pérez is remembered as a great baseball mentor in the Sunland-Tujunga community. (Courtesy of Little Landers Historical Society/Bolton Hall Museum, Tujunga, California.)

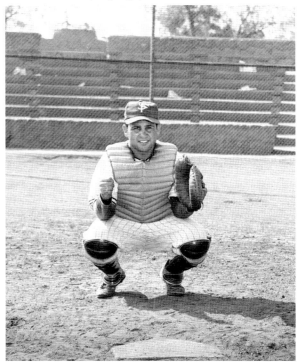

Catcher Mario Cano poses in the mid-1950s. After serving in the Navy during World War II, he managed the well-known Sunland Merchants throughout the 1950s and 1960s. The Cano family moved to Sunland from Arizona in the 1930s and were one of the few Mexican American families in the area. Mario often played for San Fernando teams and was also active on the Tujunga American Legion team. His wife, Josephine, was the first woman to play in a Los Angeles senior softball league. (Courtesy of Mario Cano Jr.)

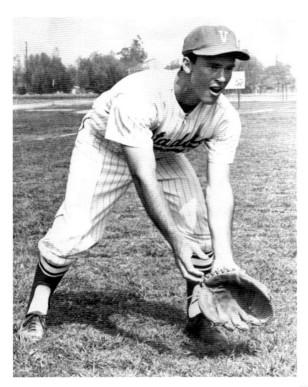

Tony Dávila, a native of Reseda, excelled as an infielder for the Matador teams of San Fernando Valley State (now Cal State Northridge), winning all-league and region awards before graduating in 1964. After college, he played in the Angels organization for three years. Dávila started a family coaching legacy at Cal State Northridge, coaching baseball and tennis throughout the 1970s and 1980s and winning two championships. His son Terry has been the head coach of men's soccer at Cal State Northridge for over 15 years. (Courtesy of Tony Dávila.)

Arnold Durazo was a shortstop on the nationally ranked 1966 Point Loma All Navy team. In the summer of 1962, he earned a spot on the Dodgers rookie team, playing games at the newly built Dodger Stadium. Durazo worked on the USS *Marias* in 1966 and served as a Marine in the Vietnam War. His grandson Nicholas Durazo continues the family baseball legacy as a pitcher at East Carolina University. (Courtesy of Jackie Durazo Murphy and Arnold Durazo.)

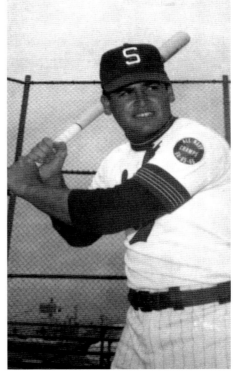

Fred Rico was called up to the Kansas City Royals in 1969. In his senior year at San Fernando High School, in 1962, the team captain batted .532 and was named the San Fernando Valley player of the year. After graduating, Rico played at Pierce College in Woodland Hills and at Arizona State University. During his first season in the majors, he hit a foul ball that his mother caught at Angel Stadium. In the off-season, Rico worked as a barber. (Courtesy of Cece González.)

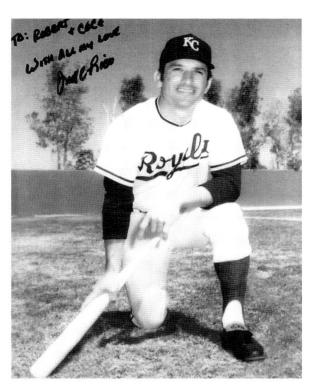

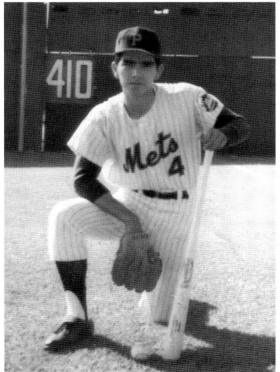

The late Richard Avalos was one of the prime talents to emerge from the San Fernando Valley. The left-handed center fielder was known for his superb hitting and strong throwing arm. Sister Gena remembers him throwing out a runner at home plate from 400 feet away in dead center field at San Fernando Park. The Pacoima native was selected in the first round of the 1970 draft, and he was signed by the Mets to a $3,000 bonus. Baseball players in the family have worn No. 4 in his honor. (Courtesy of Gena Avalos Calzada.)

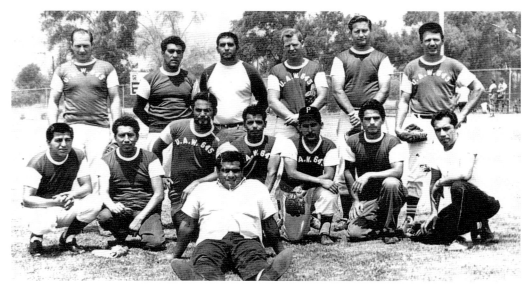

This 1960s United Auto Workers Van Nuys General Motors softball team includes, from left to right, (first row) Tommy Domínguez, Harold Vaíz, Bobby Lujan, Henry Alcantar, Ralph Márquez, Danny Gómez, and Manuel Vaíz; (second row) unidentified, Piney García Jr., Bud Martínez, and three unidentified players. The man in front is Mike Naranjo. Lujan was a standout baseball player at San Fernando High School and played on a Dodgers prospect team organized by famous scout Mike Brito. Mexican Americans represented the majority of the Van Nuys plant's several thousand workers until its closure in 1992. (Courtesy of Bobby Lujan.)

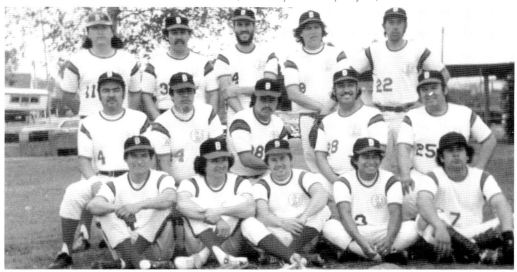

The 1973 Mid-Valley Brewers played their games in Sun Valley. The captain was Rey León (first row, second from left) who played shortstop for three years. Other team members included first baseman Carlos López (third row, second from left), second baseman Louie Corona (second row, far left), Gene Peralta (third row, far left), and manager Armando López (second row, far right.). (Courtesy of Rey León.)

3

TRANSNATIONAL AND MILITARY BASEBALL

Research on the social, cultural, and political impact of baseball and softball on the lives of Mexican Americans has largely focused on local communities. The Latino Baseball History Project has, however, uncovered countless stories of Mexican Americans who played ball outside of the borders of the United States. A handful of Mexican Americans played professional ball in Canada as part of the minor-league system of major-league baseball. Hundreds of Mexican Americans also have played ball in Mexico for minor-league teams or with independent Mexican teams and leagues. Mexican Americans born and raised in the United States have played in Mexico for almost a century. Most chose to play in Mexico rather than in the United States minor-league system or colleges for various reasons, including better salaries, larger stadiums, a chance to visit and live with family members still residing in La Patria, greater news coverage about their individual achievements, and, of course, less racial discrimination.

Military service has also been a major contributor for Mexican Americans playing around the world. During World Wars I and II, Korea, and Vietnam, and during times of peace, Mexican Americans played throughout Europe, Africa, Asia, and the Pacific region. Mexican Americans could be found on the ball fields of France, the Philippines, Germany, India, Morocco, Australia, Puerto Rico, New Zealand, Korea, Vietnam, Japan, England, Guam, Panama, Guadalcanal, Portugal, and near the Russian border. Mexican Americans who played outside of the United States came home with a greater awareness of global issues. Assisted by the GI Bill, the majority of these returning veterans became educational, political, economic, and community leaders, helping launch the post–World War II and Chicano civil rights movements.

The ongoing research into baseball and softball and its political relationship and role to the development of Mexican American communities is illuminating social and cultural dynamics beyond the traditional investigations of race, class, and gender at the local level. The study of ball adds to the understanding of these issues from an international perspective. This chapter highlights a group of these extraordinary barrio globetrotters.

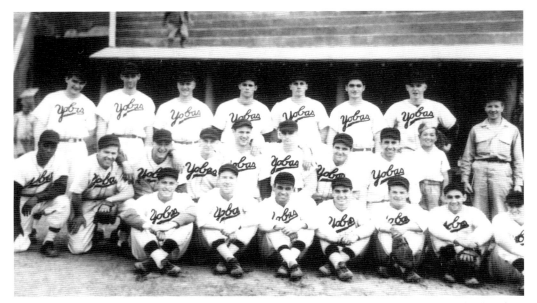

Paul Gómez (first row, left) was raised in Claremont, California, playing baseball with his brother, Tony (not shown), who was an outstanding pitcher. Both served in World War II. Paul was part of the US occupation forces in Japan immediately after the war. He played ball in several cities, including Yokohama, Tokyo, Kobe, Nagora, and Osaka. The team played before large crowds comprised largely of servicemen. (Courtesy of Raymond Gómez.)

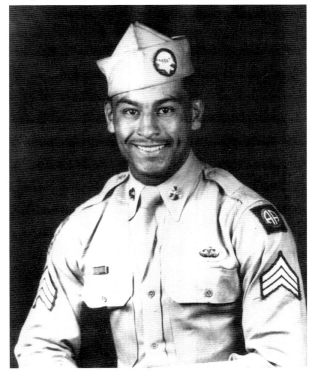

Born in Chino, California, in 1924, Jess Briones joined the US Army in 1944 and played for several military teams. He played shortstop and outfield and was an outstanding athlete with exceptional speed on the base paths and great fielding skills. Several of his coaches marveled at his accurate throwing arm, cutting down runners trying to take the extra base. Despite the long plane rides, humidity, and subpar living quarters, Briones loved every minute of his time on the diamond. (Courtesy of the Briones family.)

John Chávez completed his bachelor's degree and teaching credential at Arizona State University in June 1960. In July 1962, he was inducted into the US Army for two years, where he started pitching softball underhand. He had hurt his shoulder playing baseball in Canada and had not thrown a ball for two years. Chávez found that he could throw underhand without any pain. For the rest of his Army career, he pitched successfully for every post team he was assigned to—Fort Ord, Fort MacArthur, Fort Dix, Camp Roberts, Henry Barracks, and Fort Allen in Puerto Rico. (Courtesy of John Chávez.)

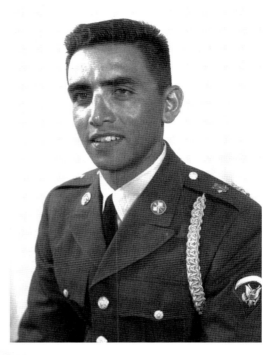

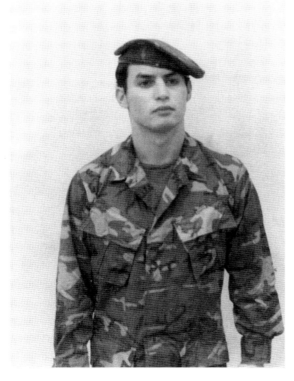

Fidel Elizarrez played ball in the US Navy while serving in Da Nang, Vietnam, in 1970–1971. His father, Gilbert, served in the Navy during World War II and in the Air Force during the Korean War. His uncle Fidel was killed during the 1944 invasion of Normandy. Fidel is named after his uncle. Before being shipped out to Vietnam, Fidel did his basic training in Coronado, San Diego, and Long Beach. He played third base against other base teams. He remembered several Mexican Americans, especially from East Los Angeles, playing on teams. (Courtesy of Fidel Elizarrez.)

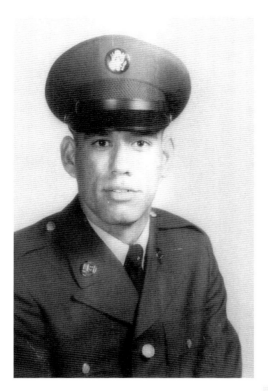

Joe F. Galindo was born in Fort Stockton, Texas. His family moved to Chino, California, in 1946. Galindo played for the Chino American Little League, Pony League, Colt League, and American Legion. He also played ball at Chino High School. He began coaching Little League at the age of 18 with Chino National. He was drafted into the Army in 1965 and, while serving his country, played baseball and basketball for the Armed Forces 45th Finance Company team in Stuttgart, Germany. (Courtesy of George Z. Gonzáles.)

George Z. Gonzáles was born in Chino, California, in 1944. He was the boyhood friend of Joe F. Galindo. The youngest of 17 children of José and Josefa Z. Gonzáles, George was drafted by the US Army in 1965 and was stationed in Kaiserslautern, Germany, with the 57th Ordnance Brigade, where he played softball and basketball. Gonzáles had three brothers who served in World War II—Pedro, Félix, and Benjamín. Benjamín was killed in action and is buried in Italy at the Florence American Cemetery and Memorial. (Courtesy of George Z. Gonzáles.)

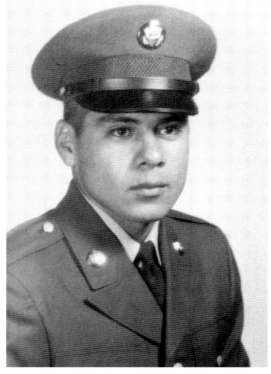

Joe Andrade had an extraordinary career in Calexico, California, where he was a star in several sports. He pitched a three-hit victory over San Diego's Hoover High School, striking out Ted Williams. Andrade received a baseball scholarship to the University of Southern California, where he met Joe Gonzáles from Roosevelt High School in East Los Angeles. Andrade had to drop out of college to take care of his family during the Great Depression. During the war, he played baseball with the Marine Corps. (Courtesy of Rosemary Andrade and Steve Binder.)

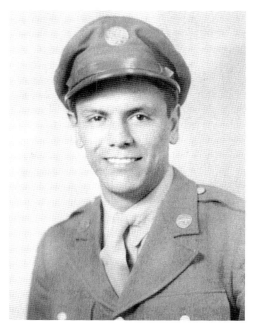

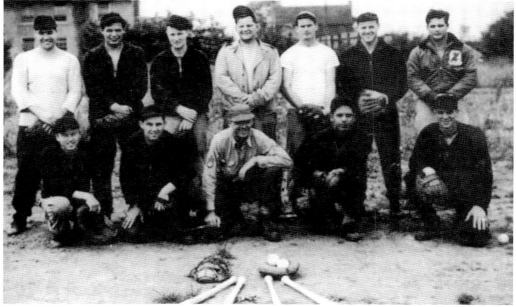

During World War II, Cpl. Ramón Martínez (first row, second from right) from Copeland, Kansas, was instrumental in forming a team for his 434th Fighter Squadron/479th Fighter Group, stationed in Wattisham, England. Ramón, a semiprofessional player for the Liberal (Kansas) Blacksox, was offered a $90-a-month contract by Brooklyn Dodger scout Bert Wells in 1939, but he turned down the offer because he was making more money and was provided a job by the Blacksox. In 1945, Martínez's squadron won the championship and was awarded a trip to Edinburgh, Scotland. (Courtesy of Rod Martínez.)

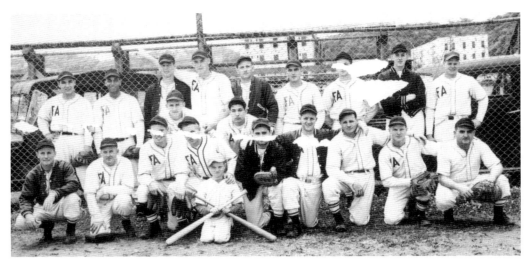

Brothers Frank (standing, far left) and Tony Galindo (second row, right) were born in Stockton, California. They were stationed in Yokosuka, Japan, in 1949, and received special permission from Gen. Douglas MacArthur to serve on the same Navy ship, an exception to military rules regarding siblings serving together. They played on the fleet baseball team, winning the championship in 1949. They were the only Mexican Americans on the team. Several professional teams, including the Indians and Yankees, wanted Frank to sign with them, but as an "Italian" and not a Mexican. He refused. (Courtesy of Randy Zaragoza.)

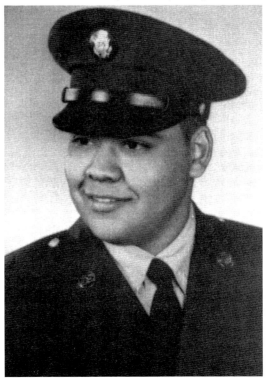

Marcus Castillo Jr. was raised in the San Fernando Valley, north of Los Angeles. His father, Marcus, had been an outstanding hitter with several teams and earned the nickname "King of the Home Run." The elder Marcus served in World War II, during which time he played military ball. Marcus Jr. followed in his father's footsteps, playing youth ball and later playing ball in the military. He served in Germany between 1963 and 1966 as an Army paratrooper. (Courtesy of Nellie R. Medellin and Ramona Valenzuela Cervantes.)

Edward D. Lyon (right) was born in San Fernando in 1897. During World War I, he was stationed at Camp Kearny in San Diego, California. Besides the regular Army drills and training activities, he engaged in organized sporting activities. Edward participated in boxing and baseball against other local Army and Navy bases. His neighborhood friend, Refugio Samora (center), was stationed alongside him. Refugio was an excellent baseball player and played on the San Fernando Merchants with Edward's brother Arthur. The man on the left is not identified. (Courtesy of Victoria C. Norton.)

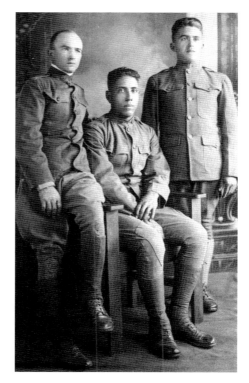

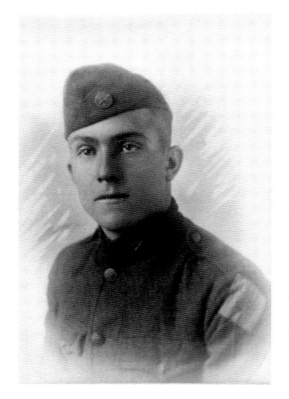

Arthur Lyon was born in San Fernando in 1898. During World War I, he trained at Camp Kearny in San Diego with the 144th Field Artillery, Battery D, and was sent to France in 1918. In a letter to his sister Irene, he writes that his team was playing a baseball game against Battery C. He played first base for the popular San Fernando Merchants in the 1920s and 1930s. He was a member of the San Fernando Super Market team that won the 1934 Athletic Association Championship. (Courtesy of Victoria C. Norton.)

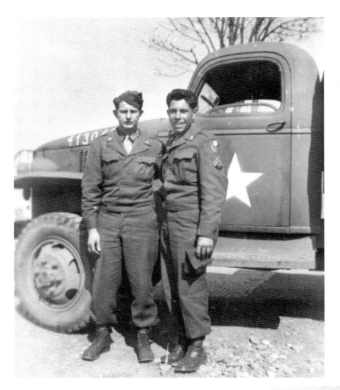

Robert Bórquez (right) was born and raised in San Fernando. He entered the Army in 1945 after graduating from San Fernando High School. While serving in Germany during World War II, he played center field for the 66th Unit. Robert married his sweetheart Millie Smith, and they raised three children. He retired as a manager from Thrifty Drug Store after 40 years and has been a member of the Kiwanis Club for over 45 years and an usher for St. Ferdinand Church since 1947. (Courtesy of Robert and Kristy S. Bórquez.)

John Fonseca was born and raised in San Fernando. He pitched for two years while attending San Fernando High School. During the Korean War, he was stationed at Sand Hill, Fort Benning, Georgia. He went to jump school for five weeks to become a paratrooper, receiving his wings and being assigned to the 508 Regimental Combat Team. He participated in Operation Longhorn in Texas. Fonseca pitched two years for the 508th Airborne, playing against other outfits, including the Army and Navy teams. (Courtesy of John Fonseca and Lorrie Carrillo.)

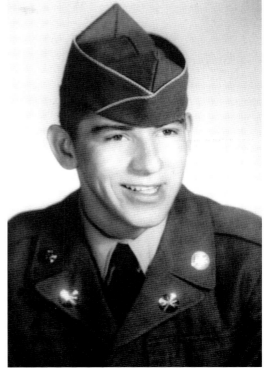

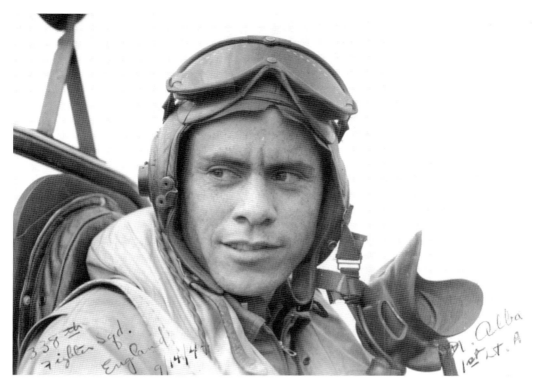

Lt. Col. Michael Alba was raised in Simi Valley in California, where his family worked in the orchards. He was a 1937 teammate of Jackie Robinson at Pasadena City College; they practiced on Catalina Island with the Cubs. A University of Redlands graduate, Alba served in World War II as a fighter pilot, and his awards include Air Force Distinguished Flying Cross, nine Air Medals, World War II Victory Medal, and Presidential Unit Citation. He is buried at Arlington National Cemetery. (Courtesy of the Alba family.)

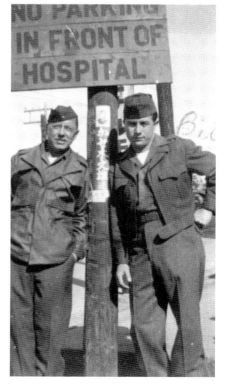

William F. Miranda (right) was born in San Fernando and excelled at baseball at San Fernando High School. He later played second base for the San Fernando Mission team that became the 1941 Southern California Mexican champions after defeating the Mexicali Mayas, the Baja California champions, in Los Angeles for the Inter-Californias International championship. While serving in World War II, Miranda was a medic at the 231st General Hospital in Japan and also played military baseball. (Courtesy of Mary Jo Moss.)

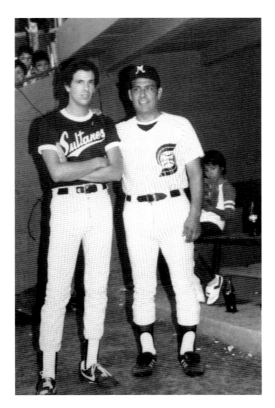

Fred Martínez (left) played for the 1984 Sultanes de Monterrey, Mexico. He is seen here with teammate Héctor Espino, the "Babe Ruth of Mexico," during Espino's farewell tour. This photograph was taken on the same field that Fred's father, Rodolfo, played on in the late 1940s. Fred played four years of ball at Lincoln High School in East Los Angeles, and later played at Whittier College, East Los Angeles College, and California State University–Los Angeles. In 1977, Martínez was drafted by the New York Mets and came up to the major leagues with the California Angels. (Courtesy of Fred Martínez.)

Fred Martínez also played ball for the Aguilas de Mexicali. Fred remembers his father and mother, Rodolfo and Maria de Jesus, listening to one of his games on their radio. The transnational cycle was now complete, as Martínez, who was born in the United States, pitched in Mexico, where his parents were born. He played winter ball in Puerto Rico and with the Vancouver Canadians, the AAA affiliate of the Milwaukee Brewers. During his two seasons with the Angels, his teammates included Rod Carew, Don Baylor, and Brian Downing, and he was managed by Jim Fregosi. (Courtesy of Fred Martínez.)

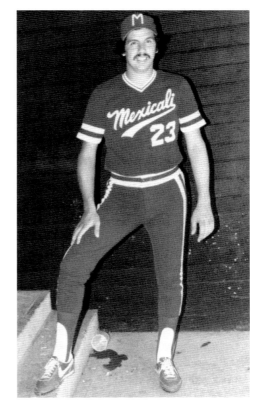

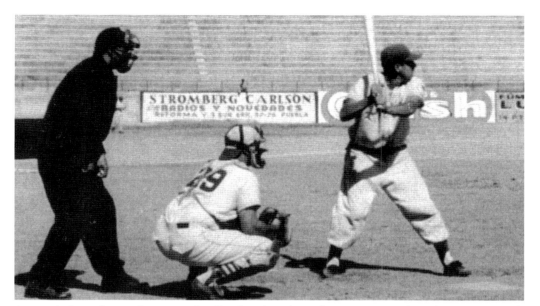

Armando Pérez (batting) was raised in East Los Angeles and was an outstanding player at Roosevelt High School in Boyle Heights. He signed with the Baltimore Orioles, played briefly with the Vancouver Mounties in the Pacific Coast League, and was with Los Pericos de Puebla of the Mexican Winter League. Mexican Americans who played in Mexico learned much about their ancestral language, culture, and history. After professional baseball, Pérez founded the nonprofit Montebello Stars Baseball Organization. Now in its 40th year, the group's theme is "Education through Baseball." (Courtesy of Armando Pérez.)

Ejido Guadalupe Victoria is the name of the town where Manuel Pérez Oliva lived in 1946, the year his son, Gilberto, was born. Manuel Pérez Oliva is the fourth from the left on this Victoria team. At fifth from left is his 18-year-old nephew Luis Pérez. Manuel's 15-year-old nephew Manuelito is at far right. Manuel was selected to the league all-star team that year. He was later selected to play in a higher division with the Aliados. (Courtesy of Gilberto Pérez.)

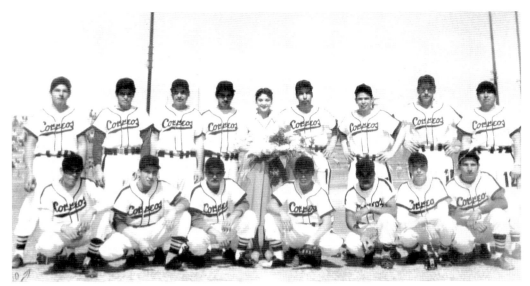

The 1954 Correos baseball club from Ciudad Juárez, Mexico, largely consisted of men who worked at the city's post office. Among those pictured are players Pedro Seanez, Victor Cordero, Tony Muñoz, Ramón Avina, Manuel Puga, Neto Lozano, and manager Luisito Hernández. Seanez (first row, far left) played both pitcher and outfielder. His two sons, Greg and Richard, later played ball in the United States. (Courtesy of the Seanez family.)

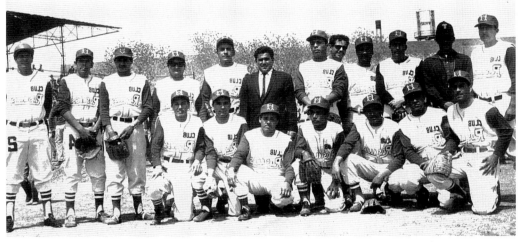

This is the 1968 Diablos Rojos (Red Devils), sponsored by Club Rosales in Ciudad Juárez, Mexico. Their games were played at Cervecería Cruz Blanca Stadium. Shown here are, from left to right, (first row) Tomas Minjarez, Francisco Hernández, Manuel Puea, Manuel Aceves, Ángel Muñoz, Mundo Télles, and Ángel Rojas; (second row) manager Francisco Cadena, Ramón Gallardo, Jesús Araiza, Oscar Alvarado, Jaime Villa, Ramón Flores, Rodolfo Adame, Pedro Seanez, his brother Jesús Seanez, and three unidentified. Pedro Seanez's two boys, Richard and Greg, were the batboys. (Courtesy of the Seanez family.)

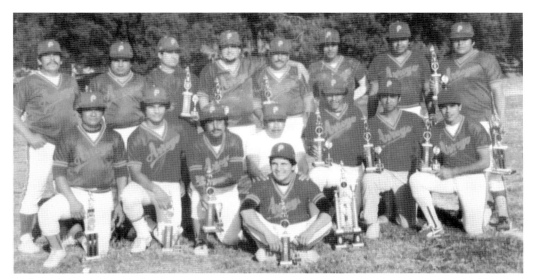

Mike Brito, a longtime Dodgers scout, has sponsored a Los Angeles league for nearly 50 years. Thousands of players have participated in the Mike Brito League. This 1983 East Angeles team, the Arroyo Colorado, includes players whose parents had emigrated from Ciudad Juárez. Among those shown here are Richie Seanez (first row, far right) and his father, Pedro Seanez (second row, far left); the González brothers Alfredo, Rubén, and Charlie; Alfred Rodríguez; Ángel Fonseca; and manager Victor Rodríguez. (Courtesy of the Seanez family.)

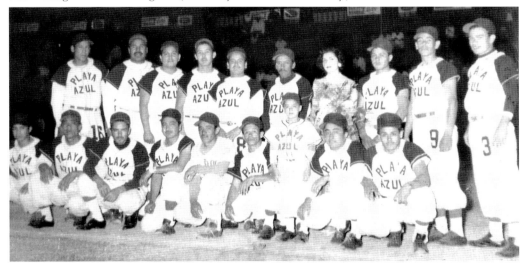

The 1956 Playa Azul team also played in Ciudad Juárez in Mexico. Posing here are, from left to right, (first row) Felipe Arvilla, Andrés Alvarado, Jesús Araiza, Chino Salazar, José Velásquez, Refugio Muñoz, Skinny Cadena (ball boy), Lupillo Mora, and Ángel Muñoz; (second row) Alfonso Flores, Lotario Ramírez, Villista Márquez, Jeronimo Romero, manager Francisco Cadena, coach Antonio Guerra, Rosita Cadena, Tony Muñoz, Pedro Seanez, and Ernesto Lozano. Skinny Cadena was the son of the manager. It was customary for Mexican teams to include one or more women in team photographs. (Courtesy of the Seanez family.)

This 1921 ship's record appears to show a team from the San Fernando Valley arriving in San Francisco in 1921 after playing games in Japan. A baseball team from the Santa Maria–Guadalupe communities had gone to Japan in 1928; it included brothers Frank and Tony Montéz. This list indicates at least three Mexican Americans making the trip: Cecil Cruz and George Bravo from San Fernando and Thomas Órnelas from Brawley, California. The Cruz brothers often played against and with teams from Imperial County, including Brawley and Calexico. (Courtesy of Victoria C. Norton.)

Mike Brito, born in Cuba, was playing in Mexico in 1955 when he signed with the Washington Senators. He played five years of baseball before becoming a scout for the Los Angeles Dodgers. Brito signed Robert "Babo" Castillo from Lincoln High School and Fernando Valenzuela. In 1968, he established the Mike Brito League, which is now in its fifth decade. Thousands of Mexican Americans have played in his league. He often found time to coach in Mexico, including with the Tijuana club. (Courtesy of Mike Brito.)

Willie Álvarez was born in Tijuana, Mexico, in 1937. Considered too skinny to play, he developed into one of Mexico's top amateur pitchers. In 1957, Álvarez was chosen to represent Baja, California Norte, in the national championship in Matamoros, Tamaulipas, Mexico. In 1966, in Baja California, he won his third state title by outdueling Gabby de la Torre, another great pitcher, for a 2-1 victory. Álvarez decided later to bring his competitive spirit and baseball skills to the United States, where he played on several teams, including the Carmelita Chorizeros. (Courtesy of Willie Álvarez.)

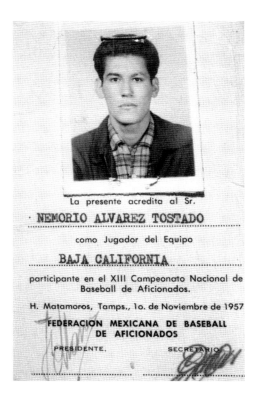

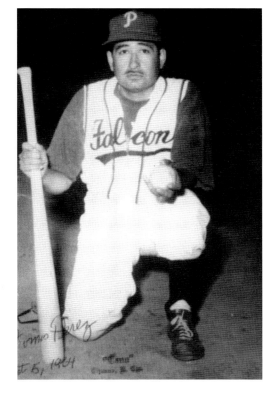

Tom Pérez Jr. was player-manager for Jean's Falcons in the 1960s. The Los Angeles–based team played for years in Baja California. Several Mexican American teams had agreements with teams in Mexico to play home and away games with each other. Some Mexican American players decided to play their entire careers in Mexico, due to higher salaries, bigger stadiums and larger crowds, and extensive press coverage. Tom's father, Tom Pérez Sr., was an outstanding player. The children and grandchildren of Tom Jr. have also played ball. (Courtesy of Tom Pérez Jr.)

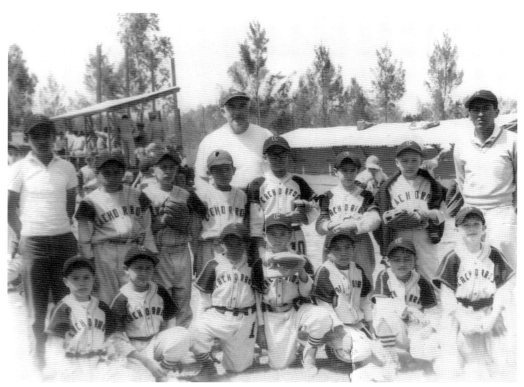

The Colegio Americano in Mexico City sponsored this 1958 Little League team, the Cachorros (cubs). The colegio was a combined grammar and middle school. Baseball was popular in Mexico, especially among people from the United States who lived there. Jorge "George" Tinajero (first row, center, holding glove) loved the game and was given the opportunity to play by manager David Linley (rear, center), even though Jorge did not attend the school. Jorge went on to play Pony League with the Lobos for the same manager. (Courtesy of Jorge "George" Tinajero.)

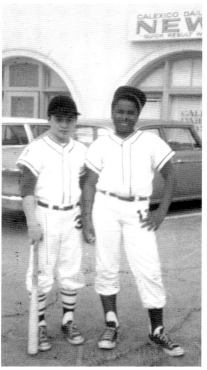

Jack Arenas (left) played for the Baldwin Park (California) Blue Jays in 1964 and is seen here at the age of 13 with a teammate. The Blue Jays, even at this young age, traveled to Mexicali, Mexico, playing against a youth team. Arenas went on to star at Lincoln High School in Los Angeles, where he was selected as the First Team All-City shortstop in 1968. He played four years of ball at East Los Angeles College and Whittier College. (Courtesy of Jack Arenas.)

Freddy González was born in 1922 in Yuma, Arizona. The family moved to Boyle Heights in East Los Angeles shortly after his birth. He played lots of ball in parks and schools and later received a scholarship to the University of Santa Clara. González played ball in the Coast Guard during World War II. He married Mary Margaret Buchanan while in the service. González moved his family to Mexico, where he played four years of baseball with several teams, including the Monterrey Blues. (Courtesy of Jim González.)

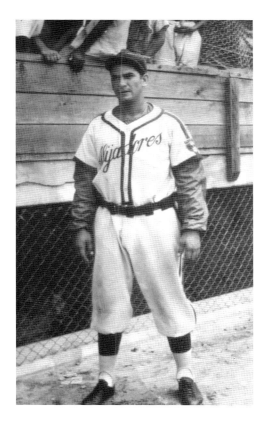

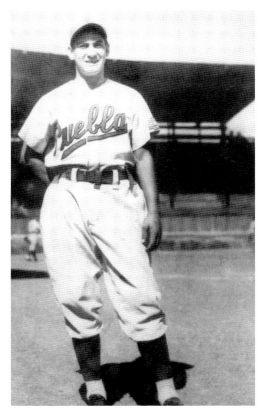

Freddy González grew up in East Los Angeles, playing baseball with his four brothers—Joe, James, Ernest, and John. All five brothers served in World War II. Ernest was killed in action, and John was wounded. Before the war, Freddy was playing in Puebla, Mexico, as a shortstop before he went into the service. He played for the Pacific Coast League's Hollywood Stars in 1945 before leaving for Mexico again. He ran a heating and air-conditioning business in Atascadero and was an avid golfer. (Courtesy of Jim González.)

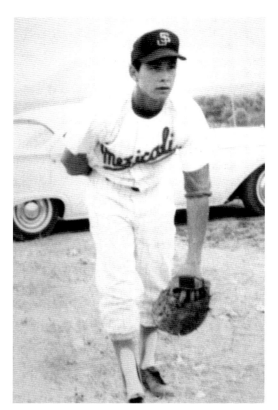

Raised playing baseball in San José, California, Gabriel "Gabby" de la Torre moved to Mexicali, Mexico, in 1964. He pitched for the Instituto de la Juventud Mexicana. As a starting pitcher for Mexicali in the 1965 Mexican National Tournament in Tijuana, Gabby struck out 40 batters against Chihuahua, winning the game 1-0 in 16 innings. The opposing pitcher, Miguel Antonio Puente, also went the distance. De la Torre's 40 strikeouts are considered a possible world record. His brother Ernie played several years in Mexico as well. (Courtesy of Gabriel de la Torre.)

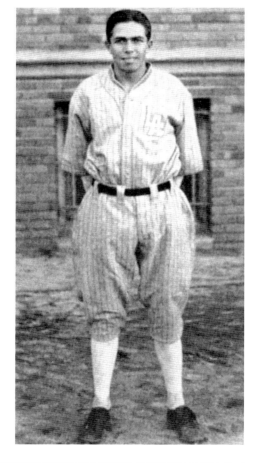

Baldomero "Melo" Almada was born in Mexico and raised in Los Angeles. He pitched Los Angeles High School to the city championships in 1930 and 1931. By 1933, Almada was the first native Mexican to play in the major leagues. He was a center fielder who was signed out of the Pacific Coast League by the Boston Red Sox. His older brother Louis became a popular player in the Pacific Coast League for the Seattle Indians and San Francisco Mission Reds from 1929 to 1937. (Courtesy of Eduardo B. Almada T.)

Juan Zapata (left) played shortstop for several teams in Mexico, including the Aguascalientes Mexican Railways and La Nueva Favorita. He was a nephew of the famed Mexican revolutionary Emiliano Zapata. During the Depression, as a single father, he put both his daughters through college by working as a master carpenter during the day and as a truck driver for the El Paso Sanitation Department at night. His daughters graduated from Texas Western College with honors and became teachers. (Courtesy of Ray Lozada.)

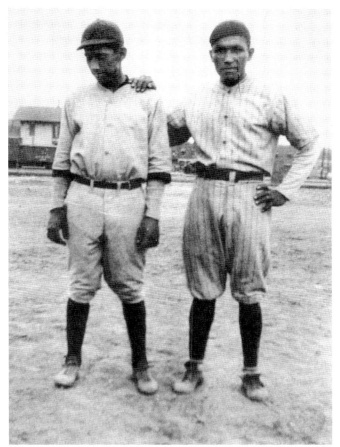

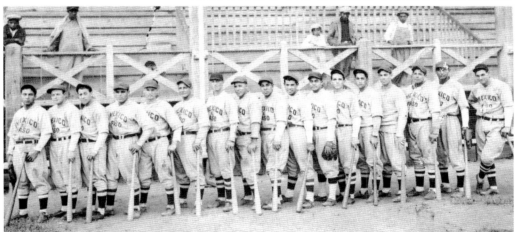

Carlos Salazar's father, David (seventh from right), is seen here in 1938 in a game in Mexico City. The team, Mexico–El Paso, was a Los Angeles–based team sponsored by a shoe store. It was one of the premier teams, recruiting the best players during the 1920s and 1930s. Nearly every great Mexican American played for the team during his career. (Courtesy of Carlos Salazar.)

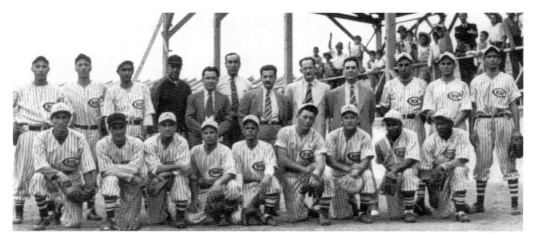

Robert "Lakes" Lagunas traveled to Mexico to play and manage teams that were quite successful in the 1930s and 1940s. He had played in Mexico in the 1920s, including for Juárez, Hermosillo, and Torreon. Robert (first row, fourth from left) was joined by his brother Raymond (first row, fifth from left) on this 1941 Chihuahua baseball team. Robert had two sons, Bob and Art, who were outstanding players at the California youth, high school, and college levels, in Canadian professional baseball, and in military ball for the United States. (Courtesy of Bob Lagunas.)

Mexico has had a long and rich tradition of outstanding teams and highly competitive leagues. The nation has produced excellent ballplayers—some who have been talented enough to play for both countries. Baldomero "Melo" Almada was the first native Mexican to play in the major leagues in the United States. He played with and against such players as Babe Ruth, Jimmy Foxx, Joe Cronin, Bobby Doer, Ben Chapman, Wes and Rick Ferrel, Charlie Gehringer, Joe DiMaggio, and Lefty Gómez. Almada is depicted on this ticket, which commemorates Mexico's 50th anniversary of professional baseball. (Courtesy of Eduardo B. Almada T.)

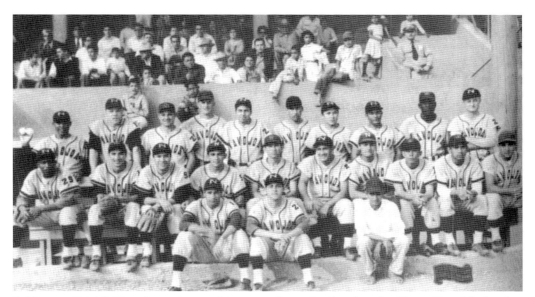

Baldomero "Melo" Almada was born in Mexico and raised in Los Angeles. He and his elder brother Louis, who was also born in Mexico, had outstanding baseball careers, helping Los Angeles High School play in championship games in 1925, 1930, and 1931. Almada played for the Boston Red Sox, St. Louis Browns, and Brooklyn Dodgers. He played and coached many years in Mexico. He is seen here (third row, fifth from left) with Los Mayos de Navojoa in the 1956–1957 season at Estadio Revolución. (Courtesy of Eduardo B. Almada T.)

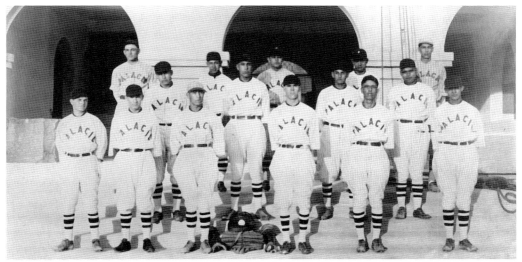

The 1923 Palacio (Palace) team poses in front of Gov. Abelardo L. Rodríguez's mansion in Mexicali, Mexico. Formerly a professional baseball player, Rodríguez later became the president of Mexico. He built the Rodríguez Dam in Tijuana, and the airport in Tijuana is named after him. As president, his chauffeur was David F. Cruz Jr. Cruz is seen in the first row, third from left. His elder brother Cecil is in the second row, second from left. Both brothers were outstanding players in the San Fernando Valley. (Courtesy of the Bacon family.)

Mexican Nine in Final Game

Stars Tangle With Colored Giants at White Sox Park Today

Mexican baseball stars from Chihuahua make their farewell Los Angeles appearance today at White Sox Park when they set out to wind up their stay here against the powerful Colored Giants. First game is at 1:15 p.m.

Manager Manuel Lagunas of the invaders has been ordered to return his team home to fill engagements with major stars now playing in Mexico. Beating the Giants today, however, will be a real task for the Mexican nine. The Giants have acquired new pitchers in "Pullman" Porter and Barney Morris, rated the class of the National Colored League, and a pair of fence-busting outfielders, "Wild Bill" Wright and Jake Dunn.

Giants.	Mexico Stars.
Hughes. 2b	D. Orozco. 2b
Snow. ss	A. Lagunas. ss
Biott. cf	M. Lagunas, cf
Spearman. 3b	Salinas. 3b
Moore. 1b	Summers. 1b
Mackey. c	Kundee. c
Wright. lf	Vierra. lf
Dunn. rf	J. Orozco. rf
Porter. p	Castanes. p
Morris. p	Cordova. p
Moreland. p	Perea. p

This article appears in the December 1, 1940, *Los Angeles Times*. Several players from the Mexican Stars were born and raised in the United States. Due largely to racial prejudice, several Mexican Americans played for Mexican teams, and these teams often competed against teams in the United States. Brothers Manuel and A. Ramón Lagunas encountered discrimination on baseball fields in the 1920s and 1930s in Texas and Arizona. Brothers David and J. Orozco were outstanding players. These four individuals also played on several teams throughout California. (Courtesy of Bob Lagunas.)

Frank Amaya (first row, far left) and John Chávez (first row, far right) were the only Mexican Americans on this Lethbridge, Alberta, Canada, semipro team in 1958. Matt Encinas and Tom Gonzáles from California played in the league. The team shown here includes two members who played professional hockey in Boston and New York. The three summers that Chávez played in the Southern Alberta Baseball League provided fun and learning experiences in both sports and life. He still has friends in Canada with whom he keeps in touch. (Courtesy of John Chávez.)

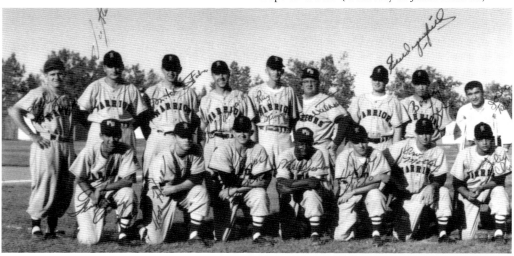

4

THE GOLDEN STATE

The Arcadia Publishing series on Mexican American baseball and softball in California has devoted one chapter per book to examining the game from a state perspective. The first book highlights the history of baseball in the Greater Los Angeles area, with a special focus on East Los Angeles. Los Angeles players shared stories with researchers about traveling to neighboring counties, including San Bernardino, Riverside, Orange, Ventura, and Santa Barbara, to play local teams. As a result of this historical revelation, the second book looks at baseball and softball in both San Bernardino and Riverside Counties. Players from these two regions reaffirmed that they had played as far south as Imperial and San Diego Counties, into Orange County, and into the central region of California. The third book, on Orange County, once again shows an amazing network of Mexican American leagues and tournaments among several counties. Amazingly, players still knew other players by name and reputation nearly 50 years after they had played against each other.

The fourth book looks at northern Los Angeles County, Ventura County, San Barbara County, San Luis Obispo County, Fresno County, and Sacramento County. New research unveiled an elaborate network of leagues, tournaments, and teams in Central and Northern California. Players as far away as Sacramento played ball in the Central Valley and Central Coast, and vice versa. The fifth book centers on Mexican American baseball and softball in the Pomona Valley. Players and teams from this region spread out to play in several surrounding counties and into Mexico, as did many other California teams.

The statewide chapter in each book reveals significant themes of Mexican American history that have been often overlooked, including the power of Mexicans to travel throughout the state to play ball despite discrimination in public accommodations. These sophisticated baseball and softball networks eventually went beyond the field, becoming political, social, and labor networks. Many of the players have testified that politics was a part of their agenda as they traveled up and down the state. On the field, they were competitive foes, but, beyond the baselines, they were political allies, linked together by a common rendezvous with history.

Irene Alba Verdugo was born in Pasadena in 1921 and raised in Simi Valley, where her family worked in the orchards. Verdugo's eight brothers played baseball, and she played on the women's softball team. Even after receiving a broken nose, Irene enjoyed playing ball. She married James Verdugo Sr. from San Fernando. Irene worked at San Fernando Hospital and at St. Ferdinand's Rectory, coordinating the priests' and visiting cardinals' meals. Irene loved the Dodgers and took a great interest in her grandchildren's upbringing. (Courtesy of James V. Verdugo Jr.)

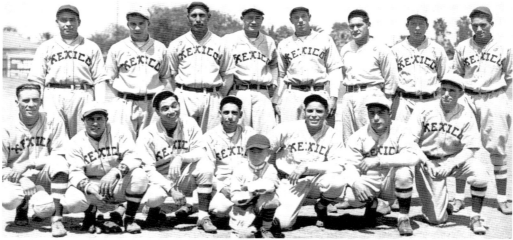

The batboy is nine-year old Greg Regalado, the eldest of four boys, who followed his father, Manuel (second row, fourth from left), the team manager, to nearly all of the games. Greg was an outstanding baseball player who starred on the Glendale High School championship baseball team in the late 1930s and played minor-league ball for Visalia after World War II. Greg's son Ron followed his father and grandfather to their baseball games throughout Southern California and in El Paso, Texas. (Courtesy of Ron Regalado.)

Raúl Gonzáles was a 16-year-old pitcher for Pan Pacific Fisheries, one of many tuna- and fish-canning enterprises that lined Fish Harbor on Terminal Island, California, for decades. Gonzáles, who grew up in a Mexican American neighborhood of San Pedro known as La Rambla, played for the team around 1949. Raúl, with his brother Richard "Tito," went on to play for other teams led by George de la Torre Sr., founder of Harbor Canning in Wilmington, California. It is now Juanita's Foods. (Courtesy of Albert and Nancy González.)

Y.B. "Lucky" Lujan was born in Stockton, California. He played on the American Legion team Karl Ross Post No. 116, which won the 1942 Northern California championship and then lost to Los Angeles for the state title. He pitched for San Diego High School, as his father moved the family for his work at the naval base. During World War II, Lucky survived twice when his ships were damaged; his injuries included a broken arm and ruptured kidney. He worked for the Stockton Fire Department and was inducted into the Mexican American Hall of Fame in 2005. (Courtesy of Steve Lujan.)

José Moises "Mousey" Zaragoza, along with others, formed a team, the Latin American Club, in Stockton, as a reaction to discrimination. The squad played other Mexican American teams throughout Northern California. The Cal-Mex League was established in 1955, with Zaragoza playing for Club Mexico. Prior to the league, he helped start a Mexican American team in nearby Woodland in 1950. Later, he played fast-pitch softball for such teams as Fiberboard, Red's Club, and the Ambler Club. Zaragoza also helped start a Mexican American basketball league. (Courtesy of Randy Zaragoza.)

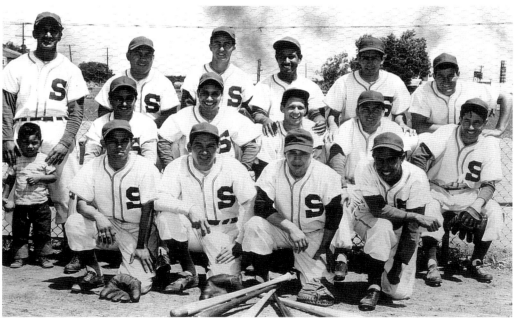

Stockton, California, has fielded outstanding teams, including this 1952 unit. Shown are, from left to right, (first row) Manuel Catario, Roy Álvarez (manager), Muggsy Moreno, and Richard Valverde; (second row) Lil Orosco (batboy), Bill Valverde, Pete Martínez, Roy Álvarez Jr., Rubén Limón, and Leo Magdeleno; (third row) Primo Orosco, R. Garabito, Ben Valverde, Sachus Orosco, José Zaragoza, and J. Crow. Zaragoza started a girls' softball team in the 1970s, and he was voted the "Most Valuable Parent" of the girls' basketball team in 1980. He also served as union shop steward. (Courtesy of Randy Zaragoza.)

Jesse Gallardo (left) and Manuel Carrasco are seen in Soledad, California, when they played for a softball team around 1939. Several towns, including Soledad, Gonzáles, Greenfield, and Salinas, sponsored teams dominated by outstanding Mexican American players. Nearly all of the families worked for agriculture, the packinghouses, and the railroads. Gallardo played and coached in Soledad for over 50 years. He coached youth ball and local school teams. Because of his unselfish commitment to the community, a local park was named in his honor. (Courtesy of Jesse Gallardo.)

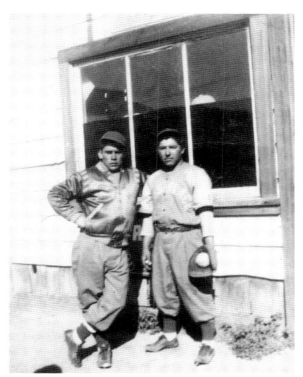

Maggie Salazar is seen here at the age of 15, when she played catcher for a 1946 women's team in Irwindale, California. Other players included Lupe Arvizo, Lupe Escobedo, Margaret Silva Barbosa, and Velia Silva. The manager was Alfred López, and the coaches were Mike Miranda and Luis Ruelas. The team was sponsored by a local gas station, Happ's. Maggie and Velia later played in Baldwin Park with a professional team, the BP Royals, thus the initials "BP" on her jersey. The team traveled to Arizona, Mexico, and Canada. (Courtesy of Maggie Salazar.)

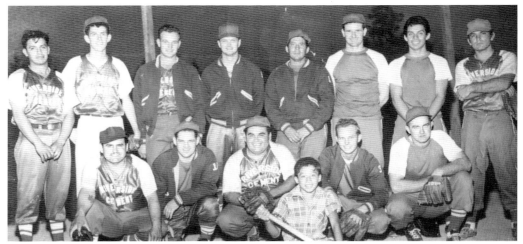

The Riverside Cement Company in Oro Grande, California, sponsored this 1953 team comprising players from both Oro Grande and Victorville. Company teams were often racially mixed, due to the diversity of the workforce. However, Mexican Americans were usually employed in lower-paying jobs than whites. Several Mexican American players are seen here, including John Guerra (first row, far left), Robert Quintanar Sr. (first row, center), Vincent Cruz (second row, far left), Martín González (second row, fifth from left), Rudy Ramírez (second row, second from right), and Cleo Vargas (second row, far right). The batboy is Manuel González. (Courtesy of Bob Quintanar.)

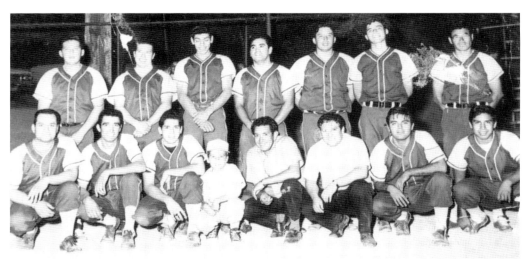

The 1966 Carmelitas Mexican Restaurant team was the Victorville, California, city champion. Shown are, from left to right, (first row) Rick Ojeda, Gilbert Lugo, Royce Bessera, Mike Lugo (batboy), Arthur Campos, Sepherino Carbajal, Butch Gómez, and Juan Sánchez; (second row) Reggie González, Paul Gutiérrez, Héctor Ramírez, Pete Moreno, Manuel González, Héctor González, and Frank Mora. Many of these players participated in other sports. Félix Díaz (not shown) played several sports, including football, basketball, and track. In 1953, he set his high school high-jump record. In 1951, he scored a touchdown on a 95-yard run. (Courtesy of Royce Bessera.)

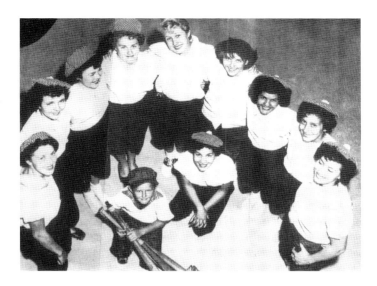

The 1953 Victorville women's team played in the Victor Valley Women's League. The four Mexican American players are Otilia Lugo Félix (far right), her sister Clemencia Lugo López (second from right), Petra Reyes Ramírez (third from right), and her sister Alicia Reyes ? (fourth from right). Nellie Martínez also played in the league. (Courtesy of Félix Díaz.)

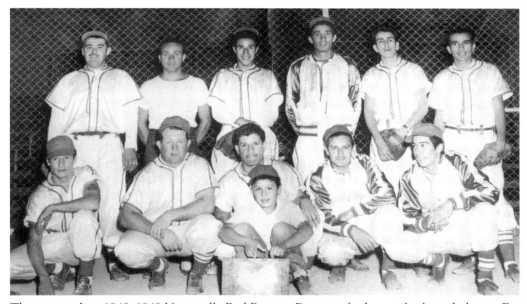

The outstanding 1948–1949 Victorville Red Rooster Bar team had several talented players. For years, the Red Roosters' archrivals were Los Lobos, from nearby Barstow. Posing here are, from left to right, (first row) Leónard Rodríguez, Guero Orantia, Sepherino Carbajal, batboy Bobby Carbajal, Salvador Rodríguez, and Humberto Lugo; (second row) Nick Patterson, Louie Aceves, David Navarro, Gilbert Lugo, Vincent Cruz, and Teofilo Hernández. The Mexican American community dates to the early 1900s in the Victor Valley. Most worked for the cement plants and the railroads. (Courtesy of Royce Bessera.)

This is the 1979 Keenan Little League Major All-Star team from La Puente, California, in the San Gabriel Valley. The Valley had many teams, which gave Mexican American boys and girls the opportunity to compete at the highest level. James Henninger Aguirre (second row, second from right) was the number-one draft pick of the Keenan major-league Yankees. Other players include Joe Fitzgerald, Tim Solíz, Leónard Martínez, Sam Manning, Steve Chávez, Jack Vigil, William Hernández, Steve Akiyoshi, and Louis Velásquez. (Courtesy of James Henninger Aguirre.)

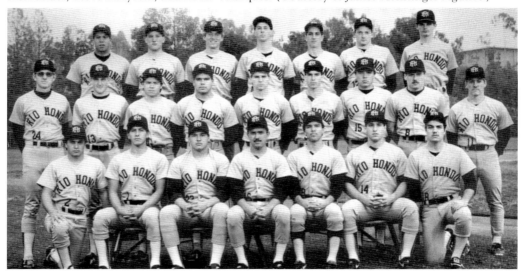

Rio Hondo Community College is located in the San Gabriel Valley, in the city of Whittier. James Henninger Aguirre (second row, third from right) was known as "Big James," because he was bigger than the other pitchers. He was not recruited by the college, but he made the Roadrunners team as a walk-on in 1985 and 1936. Other players include Rubén Campos, Kiki García, Vic Macias, Anthony Rodríguez, Steve Muñoz, and Gilbert Valencia. (Courtesy of James Henninger Aguirre.)

Joe Cortéz was a four-year varsity letterman for the Rosemead, California, Panthers team. He was the captain and, in 1960, was named the team and league most valuable player. He was the only Mexican American on the team. Later, he was the captain for both the baseball and football teams at the University of Redlands. Cortéz played four years of both sports at Redlands. In 1986, he was the first Mexican American inducted into the Redlands Athletic Hall of Fame. (Courtesy of James Henninger Aguirre.)

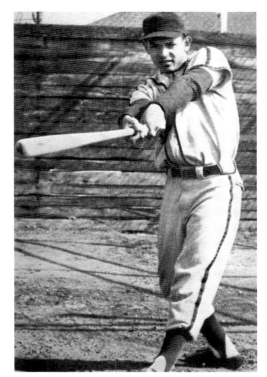

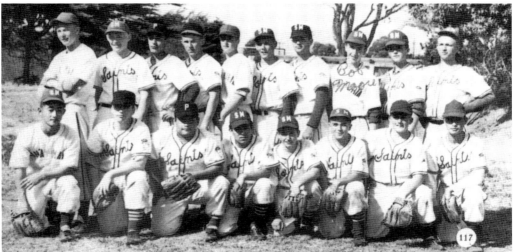

The 1955 Santa Maria High School junior varsity team had outstanding players. including Fred Lizalde, James Robles, Frank Martínez, Ernie Corral, Ted Davidson, and Johnny Ventura. The Lizalde family from nearby Guadalupe produced outstanding athletes. Fred played baseball and football in high school, football at Allan Hancock Junior College, and football at Sacramento State College, where he earned his master's degree. Ventura's son, Robin, played professional ball for the White Sox, Yankees, Mets, and Dodgers, and he is currently managing the White Sox. Davidson went on to play for the Cincinnati Reds. (Courtesy of Eddie Navarro.)

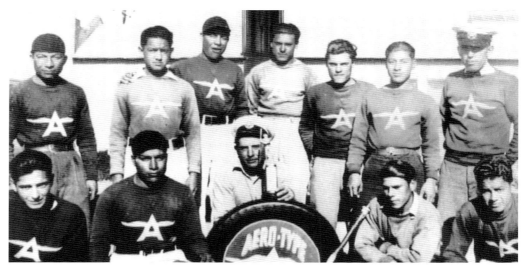

Many Mexican American teams were sponsored by gas stations, including this 1930s team from both Santa Maria and Guadalupe, California. The Almaguer family had eight brothers who played, including four on this team—Manuel (first row, second from left), Tony (second row, far left), Luis (second row, third from left), and Carmel (second row, second from right). Several of the brothers had a chance to play professionally, but their father refused because they had to work in the fields to help the family. (Courtesy of Guadalupe Cultural Arts and Educational Center/Sports Hall of Fame, Al Ramos, and the Almaguer family.)

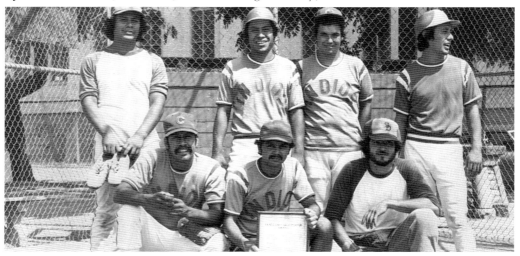

Elías and Jacinta De La Rosa migrated from Fabens, Texas, to Los Angeles in 1956, raising nine children. Softball was a deep-rooted family affair, as they enjoyed picnics on Sundays watching games. The De La Rosa brothers formed a family fast-pitch softball team, the Indios, in Boyle Heights. The team included De La Rosa brothers Cuco, Al, Frank, Rubén, and Elías Jr., brothers-in-law Frank López and Raúl López, and close friends Gerardo López, Mando Subía, Peter Ramírez, and Danny López. Elías De La Rosa Jr. (first row, left) earned a Bronze Star in Vietnam. (Courtesy of Frank De La Rosa.)

The 1967 Lincoln High School Tigers baseball team from Los Angeles won the Northern League title. The team was honored at the Golindrina Restaurant on Olvera Street. Those shown are, in no particular order, players David Vidaurrazaga, Gilbert Baltazar, Héctor Chaidez, Gus Martínez, Teddy Peacot, Jack Arenas, George Fernández, Robert Duran, Robert Lovato, Louis Ramírez, Paul Franco, Ray Lara, Melvin Pride, Victor Morales, and Rodolfo Martínez, along with coach Dave Chávez. Coach Chávez, a graduate of Garfield High School in East Los Angeles, was an outstanding baseball mentor for years. (Courtesy of Rodolfo Martínez.)

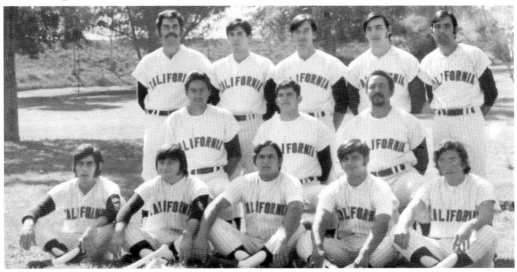

The 1974 California Stars players are, from left to right, (first row) Ray Lara, Jack Arenas, Bob Murietta, David Vidaurazaga, and Nacho Muñoz; (second row) Lencho Vásquez, David Armenta, and Carlos Nix; (third row) Ray Loya, Paul Franco, Frank Seanez, Félix Garza, and David Ferrell. Lara was the stolen-base champion four consecutive years in the Mike Brito League. (Courtesy of Chris Kolotzis.)

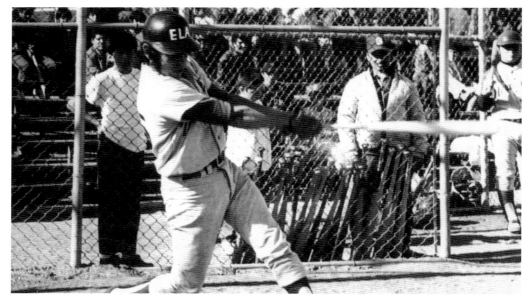

Ray Lara was born in Chihuahua, Mexico. His father was a city policeman in Mexico who later made a career as an auto mechanic. His mother, Avelina, raised four siblings. Eldest brother Fred served in Vietnam, having taught Ray the art of pitching in Mexico. Brother Jess graduated from the University of California at Los Angeles. While at Lincoln High School, Ray set a city ERA record of 0.47 that still stands. While hunting, he suffered a gunshot wound to his pitching hand, ending his chances of professional ball. (Courtesy of Chris Kolotzis.)

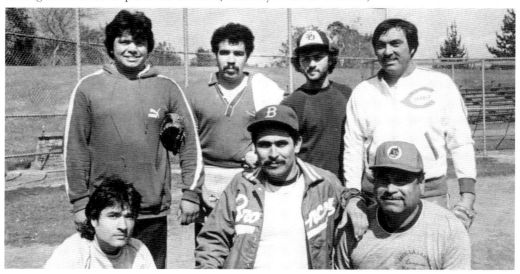

During his 1982 holdout against the Dodgers, Fernando Valenzuela worked out at local parks. This photograph was taken at Crystal Springs Park in Los Angeles. Shown are, from left to right, (first row) Moqui De Marco, Ray Lara, and Chalu Villaseñor; (second row) Valenzuela, Chino Villanueva, Johnny ?, and Mario Malvido. De Marco is the son of Tony De Marco, the business manager for Valenzuela in his early career. (Courtesy of Ray Lara.)

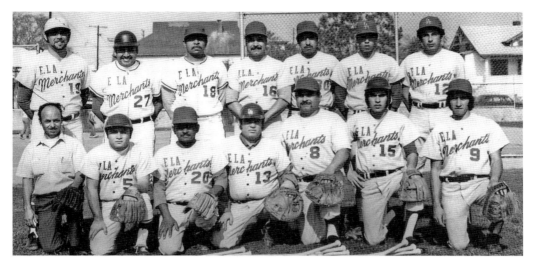

The East Los Angeles Merchants was a powerful team in the 1960s. The team's members are seen here in 1971 at Evergreen Park in East Los Angeles. Shown are, from left to right, (first row) Carlitos Morales, Jack Arenas, Ramiro Péres, Cylindro Santillán, Alfonso Villaseñor, Ray Lara, and Joel Palomares; (second row) Ray Loya, Tacho Morales, Carlos Nix, Alberto Villaseñor, Lencho Vásquez, Paul Franco, and Rudy Martínez. The Merchants changed their names to the California Stars. The team was known for physicality and high-octane passion on the field. (Courtesy of Jack Arenas.)

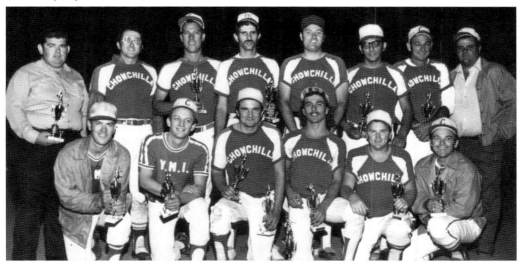

John Chávez (second row, third from right) played on this 1980 Chowchilla, California, team. It was one of 40 teams for which he played during his 20-year softball career. From 1963 until 1983, he pitched against top-level open division teams in Central California, until he was 45 years old. He pitched about 50 games a year, winning about 85 percent of them. This photograph was taken in Hollister after the team had won its third consecutive Open Division Softball Tournament in three weeks. Chávez found time to earn his master's degree in school administration. (Courtesy of John Chávez.)

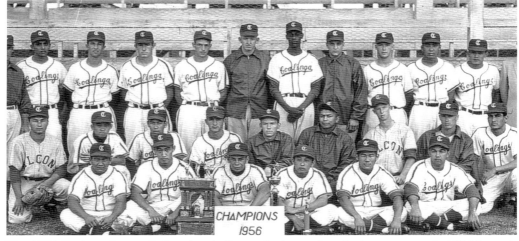

The 1956 Coalinga Junior College baseball team had an unheard-of season record of 37-0 by mid-May. Coalinga lost the last two games to the Orange Coast College Pirates for the State Junior College championship. John Chávez (third row, first player from left) had a pitching record of 14-0. He was given a scholarship to Arizona State University, where he played in 1957 and 1958. He was the first Mexican American to receive a baseball scholarship. Chávez was inducted into the West Hills (Coalinga) College Athletic Hall of Fame in 2012. (Courtesy of John Chávez.)

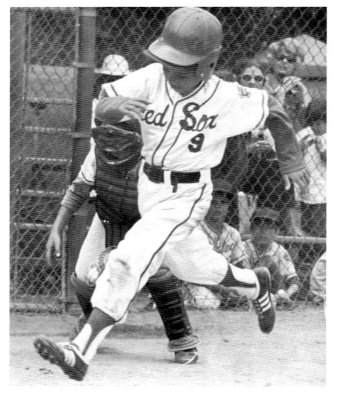

John Ramos attended Loyola High School, where he played on the football team while helping San Marino Pony League win the regional championship. At UCLA, he met Jose Blanco, whose uncle, Abel Vásquez, worked for a company that sponsored a team in Guadalajara. After graduation, Ramos went to Mexico to play ball. Since 1994, he has also played for the Burbank Adult Baseball League, Mike Brito League, and Los Angeles Baseball League. He serves with the US Navy and has been deployed to Afghanistan and the Persian Gulf. (Courtesy of John Ramos.)

Norbert Castel De Oro played baseball for his Local Union 630 in 1951. He was employed with the Los Angeles Produce Market in downtown Los Angeles. Norbert played the position of catcher and was a force to be reckoned with. Tough both on and off the field, Norbert was born the second child to Louise and Sylvian Castel De Oro, immigrants from Mexico. His father died at an early age, so Norbert quit Jefferson High School to be the sole provider for his mother and younger siblings. (Courtesy of Jaime Castel De Oro.)

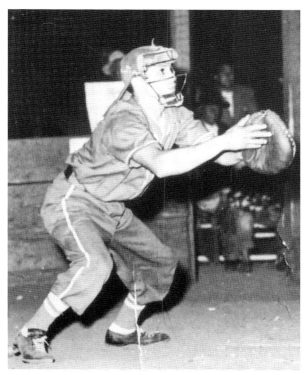

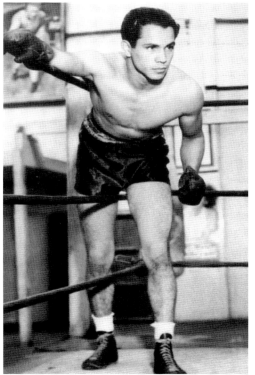

Norbert Castel De Oro was extremely passionate about the game of baseball, as well as boxing. He spent much of his free time engaging in both activities. He joined the US Navy in 1940 and served as an MP. Norbert began boxing prior to the Navy, continued while in the service, and, when he was discharged, boxed at the Olympic Auditorium and Hollywood Palladium as a welterweight. Several Mexican American ballplayers were also outstanding boxers. (Courtesy of Jaime Castel De Cro.)

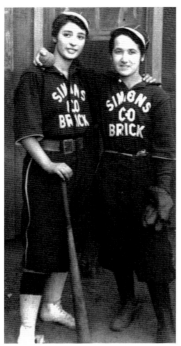

Pictured in 1915 are Simons Brickyard players Maggie Montijo (left) and 17-year-old Mary Cano. During the early 20th century, the brickyard company town of Simons, located in Montebello, included over 1,000 Mexican American residents, a company store, school, church, and post office. In 1922, Cano moved to Van Nuys, where her family worked at Van Nuys Brick & Tile. (Courtesy of Virginia Ruiz Durazo and Theresa Tresierras Durazo.)

From its beginnings, the Simons Brickyard Company sponsored several sports teams. This early-1900s photograph includes a handful of Mexican American players. Their identities are not known. Simons sponsored teams until the early 1950s. A *Montebello Messenger* reports that the Simons Athletic Club won a doubleheader. Some of the players mentioned are Alfonso Guerra, team captain Mike Rodelo, Victor González, John Hernández, Andy Elizarraz, Tony Sánchez, Albert Martínez, Tony Villa, Victor Arroyo, Carlos Morales, Vincent Díaz, and Vincent Olagué. The manager was Albert Martínez. (Courtesy of Ray Ramírez.)

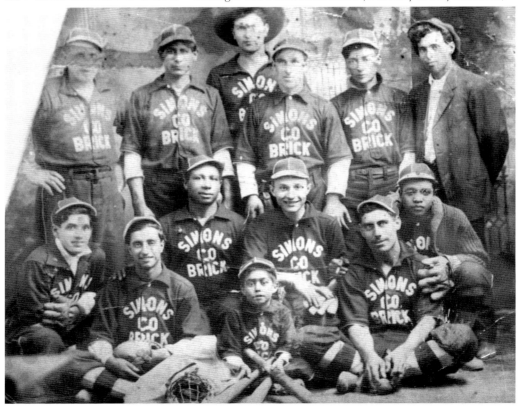

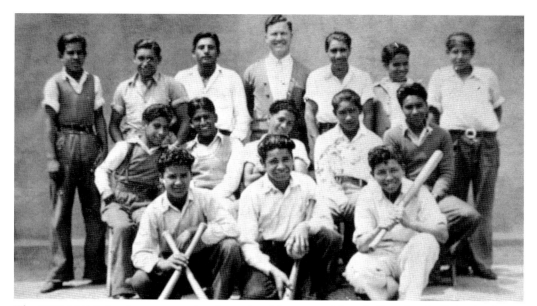

The 1933 Vail School team won the championship among Montebello schools. Salvador Leyva (first row, center) was born in Kansas City, Kansas, in 1916. His family moved to Gary, Indiana, and then to Chicago, Illinois. During the Depression, the family moved to California, where his father, Jesús, found work at the Simons Brickyard in Montebello. Salvador married Esperanza Guerra, and they had two daughters, Anita and Juanita. Salvador's nephew Fernando signed with the Los Angeles Dodgers. Beto Vásquez is holding the two bats. (Courtesy of Anita Leyva.)

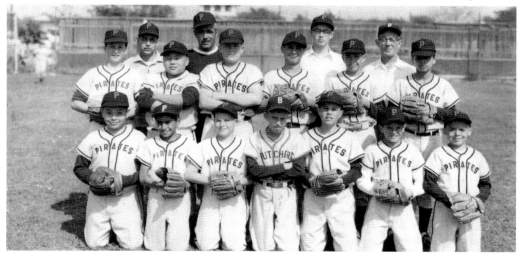

Fidel Elizarrez (second row, fourth from left) was raised in East Los Angeles, where his grandfather Ignacio took him to watch the Mexican League games at Evergreen Park. He learned to play at that same park. In 1956, when he was seven, Fidel's family moved to Montebello. He played six years of Little League ball, including two years with the Pirates. Other Mexican Americans with the Pirates included Mario Valadez, Tony Pérez, Frank Rodríguez, and Ray Arce, as well as coaches Ray Arce Sr. and Tony Pérez Sr. (Courtesy of Fidel Elizarrez.)

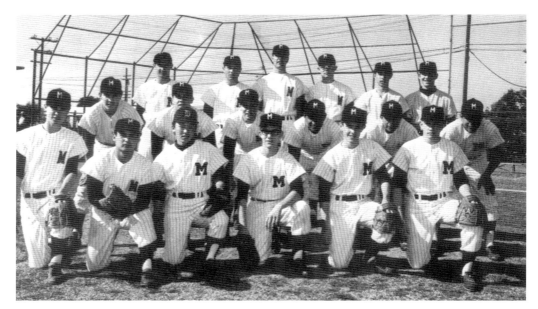

From 1963 to 1966, Fidel Elizarrez (first row, second from left) played second base for the Montebello High School Oilers. In his senior year, the team won the Pacific League Championship, beating Arcadia at Blair Field in Long Beach. Some of the players on the team were Mike Torres, Ben Negrete, and Jerry Rodríguez. Torres was signed by the New York Yankees; Negrete played ball in Mexico; and Rodríguez is the nephew of the legendary player Ernie Rodríguez. After graduation, Fidel played for Connie Mack Baseball, American Legion, and the Montebello Stars. (Courtesy of Fidel Elizarrez.)

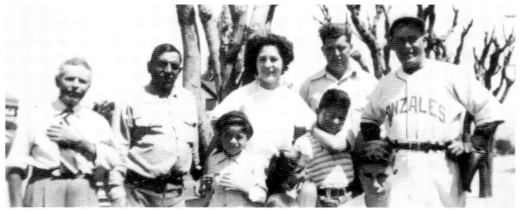

John "Juan" Martínez (wearing a Gonzáles uniform) is seen here with his family and friends in front of his house on Eighth and Belden Streets in Gonzáles, California. He was born in 1905 in Fillmore, California, but his mother moved to Gonzáles. John would go on and play baseball and softball for over 40 years. The teams often included players of other nationalities, including German, Portuguese, Swiss, and Mexican. He was the first city employee hired when Gonzáles was incorporated around 1947. His sister Angie and her children are shown here. (Courtesy of Juan Martínez.)

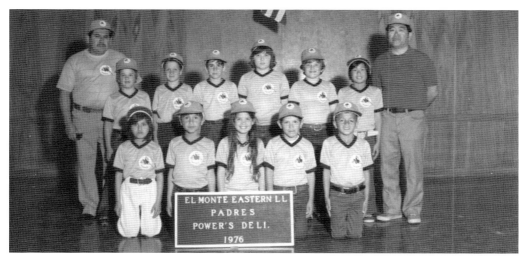

The 1976 El Monte Padres had two girls on the team. Ann Marie Castillo (first row, far left) was the daughter of manager Domingo Perfecto Castillo (standing, left). Castillo had moved his family from East Los Angeles to El Monte to establish teams as a way to keep the youth away from trouble in the streets. He managed for six years, and his daughter played for four more years. To this day, many of his former players come back and thank Domingo for guiding them to the right road to success. (Courtesy of Ann Marie Castillo.)

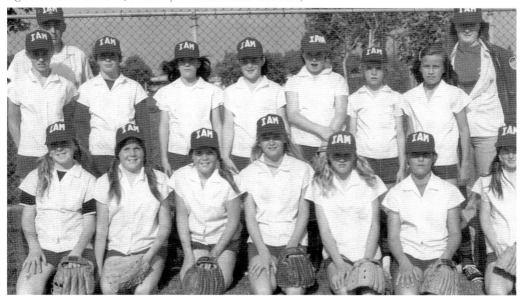

Darlene Salazar, the daughter of David and Hope Salazar, played for the 1972 IAM softball team in Montclair, California. She used her mom's glove at the time, but her parents later purchased a glove for her, since she loved playing. Darlene played right field and remembers a couple of other girls who were Mexican American. The team was undefeated, winning all 10 of its games. She was the youngest player on the team. Darlene is seen here in the second row without a cap. She played two years. (Courtesy of David, Hope, and Darlene Salazar.)

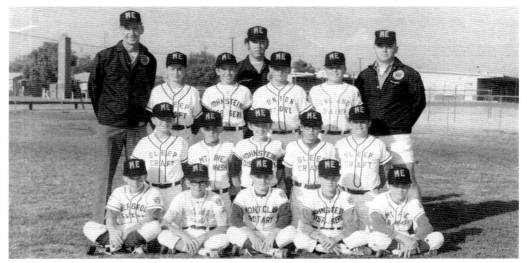

Ed Salazar (second row, second from right) played for the Montclair 1971 Eastern All-Star team. He recalled that he did not pitch in either all-star game, nor did he play at all. The son of a coach was started over Salazar, as it was felt that the manager preferred a white pitcher. The fans were yelling at the manager to start Salazar, but to no avail. Both white pitchers lost to the Central All-Stars. The only other Mexican American was Tom Baca (second row, second from left). (Courtesy of Ed Salazar.)

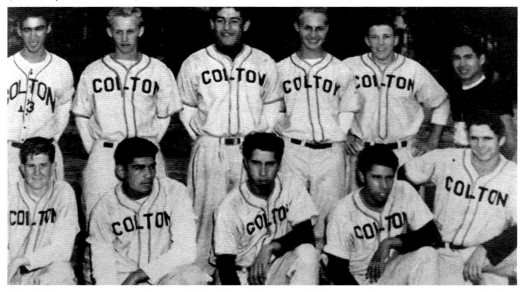

The 1951 varsity team at Colton High School has several Mexican American players, including Pio Carreon, Ernie and Manuel Abril, P. Galindo, T. Hernández, and H. Gonzáles. Pio (first row, second from left) is the brother of Camilo Carreon, who played many years with the White Sox, Indians, and Orioles. Ernie (first row, third from left) and Manuel (first row, fourth from left) are still known as "Los Cuates" (the twins). They played in Mexico, in the US military, and in the Pirates minor-league system. They still reside in Colton. (Courtesy of Ray Rodríguez.)

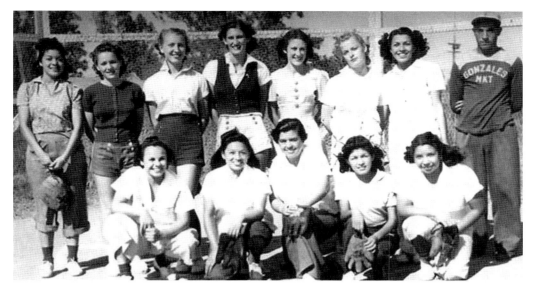

Gonzáles Market in Compton, California, sponsored a women's team in 1939. The market still operates on Willowbrook Avenue. Esther Rubio (second row, second from right) was born in Arizona and moved with her family to Compton when she was 15. She attended Willowbrook Junior High School and Compton Community College. Esther worked several jobs supporting the troops during World War II. She married Raul Ancira, an Army/Air Force serviceman, in Long Beach. She currently lives in South Gate. Her son Roy is a retired Los Angeles County fire captain. (Courtesy of Roy Ancira.)

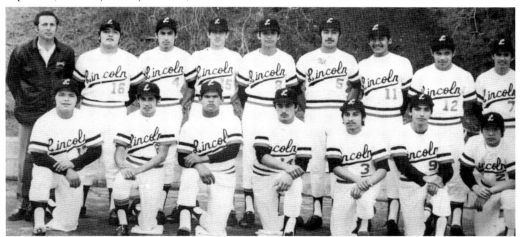

During the 1960s and 1970s, the Lincoln High School Tigers fielded several outstanding teams, including this one, which included Bobby Castillo. He would go on to have an outstanding major-league career with the Dodgers and Twins. He passed away in 2014. Shown here are, from left to right, (first row) Simón Ortega, Elizar Lozano, Robert Murieta, Bobby Castillo, Felipe Vásquez, Manuel Hernández, and Yip Quan; (second row) coach Carl Brio, Frank Martínez, Richard González, Greg Broomis, David Duran, George Balles, Robert Alcarez, Robert Guzmán, and Daniel López. (Courtesy of Al Padilla.)

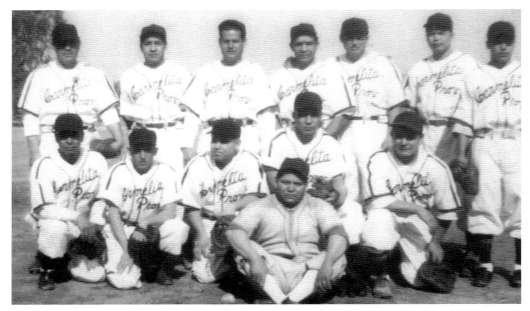

The Carmelita Provision Company in East Los Angeles was one of the few local markets that sold popular Mexican food, such as pigs' feet, pork rinds, and pork sausage. The team was popularly known as the Chorizeros (the sausage makers). The 1947 team is seen here at Evergreen Park. Manuel "Shorty" López (sitting) was the manager for many years. Among the players are Ray Armenta, Joe Correa, Al Castañeda, "Chavalo" Zumbía, Ernie Sierra, Sandy Sandoval, Freddy and Yam Yánez, Lefty Ocampo, and Richard Peña. (Courtesy of Richard Peña.)

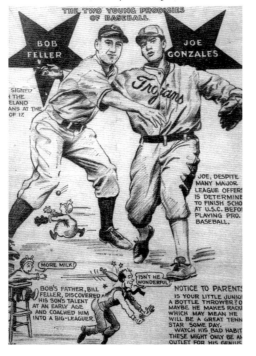

Joe Gonzáles was born in San Francisco and attended Roosevelt High School in East Los Angeles, where he learned to pitch from coach Coney Galindo, making all-city honors. He later led the University of Southern California (USC) to two Pacific Coast Conference championships. Gonzáles has been inducted into the halls of fame of both USC and Roosevelt High School. He and his four brothers served in World War II. He taught for 30 years, winning six baseball championships. Gonzáles was also the first Mexican American official in the National Football League. (Courtesy of Al Padilla.)

5

ORANGE COUNTY

Some of the players in this chapter have family histories that date to the first explorers and settlers in Orange County. The Yorba family are descendants of Jose Antonio Yorba, who came to California in the 1769 Portolà Expedition and established Rancho Santiago de Santa Ana. The Nieblas family of San Juan Capistrano has deep attachments to Mission San Juan Capistrano, dating back to 1778, and to the Juaneno Indians, who were living there long before the area was conquered. The Ruiz family has a link to Maria Rita Ontiveros-Ruiz from Rancho Las Bolsas.

Other players come from the colonias and barrios in Garden Grove, Santa Ana, Orange, and Placentia. Colonia 17 in Garden Grove was located one mile west of the old downtown, at Seventeenth Street and Verano Road (now Euclid Street). Colonia Santa Anita in Santa Ana, located on the west end, got its name from the neighborhood park named Santa Anita. The Delhi barrio, also in Santa Ana, on the southeast side on Delhi Road (Warner Avenue), is the oldest barrio in the city. Delhi barrio got its name from land purchased by two McFadden brothers who came from Delhi, New York. The Cypress Street barrio in Orange revolved around the Friendly Center, a community gathering place for Mexican Americans. Colonia La Jolla in Placentia was the center of Valencia orange growing and packing. On March 3, 1938, a flood destroyed almost everything except a school and a few brick buildings.

Between 1930 and 1940, baseball and softball grew extremely popular, though segregation forced many Mexican American players to form competitive community-based teams that played within and/or against other colonias and barrios. Due to World War II, bracero camps were being established in nearby colonias and barrios, and players had ties to these bracero families as well. Braceros were Mexican workers allowed to enter the United States for a limited time, but many stayed, filling the shortage of American agricultural workers due to military enrollment. As the industrial era developed, Mexican American teams began being sponsored by local factories, businesses, churches, legions, and clubs. For the Mexican American players in this chapter and their families, this meant spending weekends with their compadres—enjoying life, having fun, and celebrating their heritage.

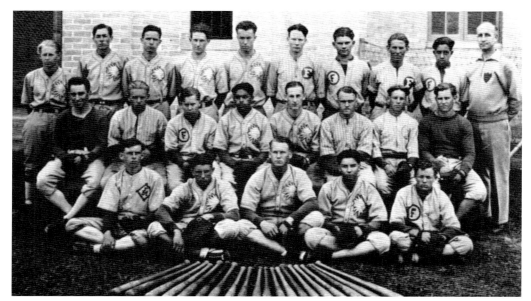

The second team for the 1930 Fullerton High School baseball season included 18 boys. Juárez, Padilla, and Ybarrolla were Mexican American players on the team. Though the team did not have any league schedule, it played several schools and made a good game of every contest. (Courtesy of Fullerton Public Library.)

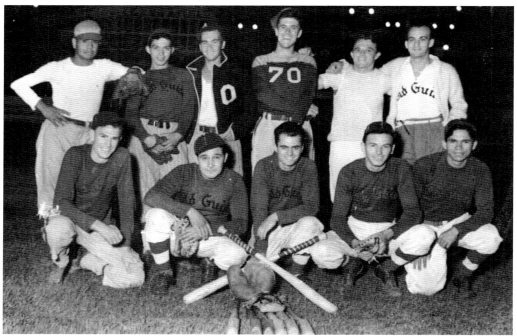

The 1936 Old Guide softball team featured top players from the city of Anaheim, Ray Ortez (second row, far left) and Henry "Hank" Ruiz (second row, second from left). Ortez was a junior and Ruiz was a senior at Anaheim High School. (Courtesy of Monica Ortez.)

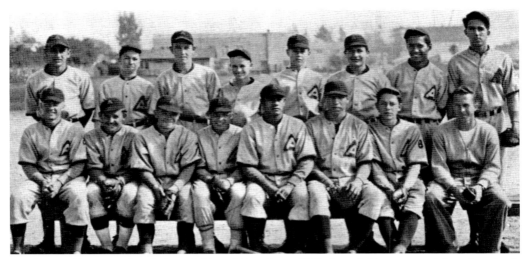

Hank Ruiz (first row, fourth from left) and Ray Ortez (fifth from left) were good friends in high school. They played varsity baseball and softball for the Anaheim High School Colonists. The highlight of the 1936 baseball season was a no-hit, no-run game pitched by Ortez against Santa Ana. He was the team captain of the softball team that same year. Coached by the famed Dick Glover, this team included other varsity regulars William Morales, Jimmy Nuñez, and Chris De Soto. (Courtesy of Anaheim Public Library.)

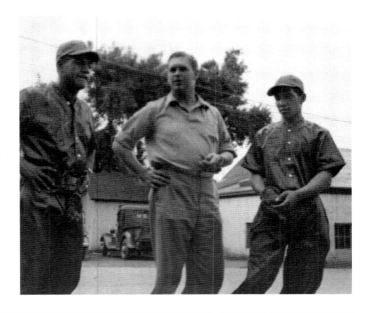

In 1937, softball player Hank Ruiz followed his buddy Ray Ortez to Prescott, Arizona, after Ray's graduation from high school, where they played on the same softball team, Prescott Tavern. Here, Ruiz (right) and Ortez (left) talk with the Prescott Tavern team's manager. Ruiz also played for several softball teams in Central California, as did Ortez. World War II began, and softball declined, so Hank entered California State University at San José. (Courtesy of Monica Ortez.)

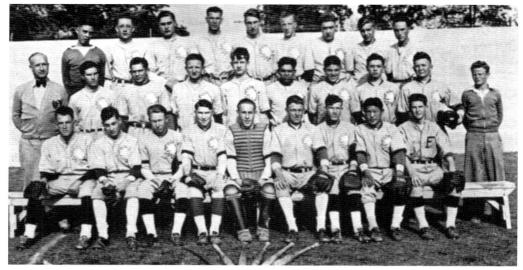

Fullerton Union High School (FUHS) was established in 1893 and, at the time, was the second high school in Orange County. The school began in a rented second-floor room of the Fullerton Elementary School. FUHS started with 8 students and 34 books that made up the library. In 1937, Bernardo Marcus Yorba II (second row, sixth from left) did pitching duties for the Fullerton Union High School second team, winning 11 of 16 games. Bernardo is a direct descendant of the historic Yorba family of Orange County that established Rancho Santiago de Santa Ana. Bernardo enlisted into the Army Air Forces on March 25, 1942, and served in World War II to its completion in 1945, achieving the rank of captain. (Courtesy of Fullerton Public Library.)

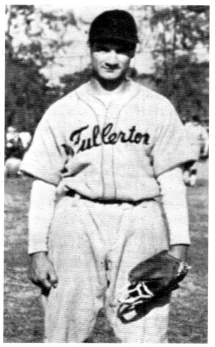

A native of Orange County, born in Stanton, Ernest Villaseñor played first base for the Anaheim High School Varsity baseball team from 1931 to 1935. In 1935, his senior year, Ernest was selected by his baseball peers as captain of the Colonists baseball nine. After graduation, Ernest attended Fullerton Junior College (FJC), the oldest community college in continuous operation in California. FJC was established in 1913 by the governing board of Fullerton High School as a two-year postgraduate course of study at the high school. In 1922, FJC was reorganized as an independent junior college. Ernest attended Fullerton Junior College from 1936 to 1937 and pitched only for the 1937 baseball season for the Fullerton Hornets. Ernest was also a leading hitter with a .539 batting average that season. (Courtesy of Fullerton Public Library.)

Born January 7, 1886, Ray Ortez Sr. was manager of the Anaheim Merchants baseball team that played in the Los Nietos Valley Manager's Association League. The Anaheim Merchants teams was comprised up of top-notch Anaheim High School, junior college, and up-and-coming good baseball players. Other Orange County teams in the league were Stanton and the Placentia Merchants. The 1938 opening season ball game was postponed by one week due to the great Santa Ana Flood. In his younger years, Ray worked as an agriculture laborer, a cement worker, and manager for a cement plant on the edge of town. Ray had only one son, Ray Jr., by his first wife, whom he married in 1913. (Courtesy of Monica Ortez.)

The Anaheim Aces were part of an independent franchise of the professional Class C California League. Opening night was April 22, 1941, at La Palma Park Stadium in Anaheim. Featured players were Eddie Reyes (second row, center) and Joseph Dominic Hurate (not pictured). The Aces team was short-lived, lasting one year. (Courtesy of Mrs. Eddie Reyes.)

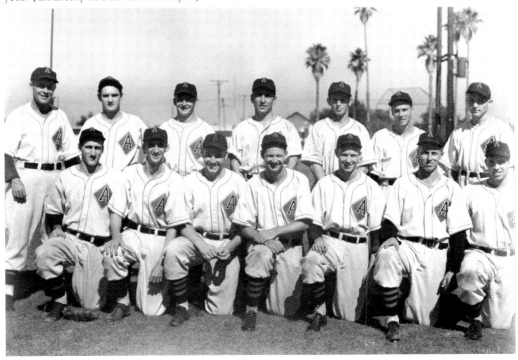

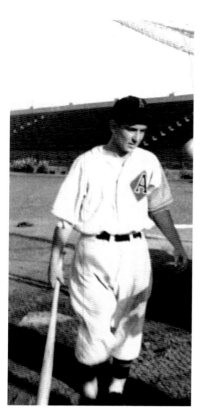

Eddie Reyes is pictured at batting practice with the 1941 Anaheim Aces professional baseball team. Eddie joined as a second baseman during the second half of the season. His baseball talents stemmed from his uncle Guillermo "Yamo" Ornelas, who was the cofounder of the Mexican Professional Baseball League in Mexico and who also played during the 1930s. Guillermo was also a US baseball scout for the St. Louis Browns and the Cleveland Indians of the American League. In addition, Eddie's family roots trace back to both Mission San Diego de Alcalá and Mission San Gabriel de Archángel. Mission San Diego was the first in a chain of 21 missions throughout California established in 1769. Mission San Gabriel was the fourth mission, established in 1771; both missions were founded by Father Junípero Serra. (Courtesy of Mrs. Eddie Reyes.)

Joseph Dominic Huarte was the original team manager and utility player of the 1941 Anaheim Aces professional team. Huarte played a total of seven years in professional baseball with other teams. He and his wife, Dorothy Catherine Eickholt, became citrus and avocado ranchers on the far east end of Anaheim from 1935 to 1995. (Courtesy of John G. Huarte.)

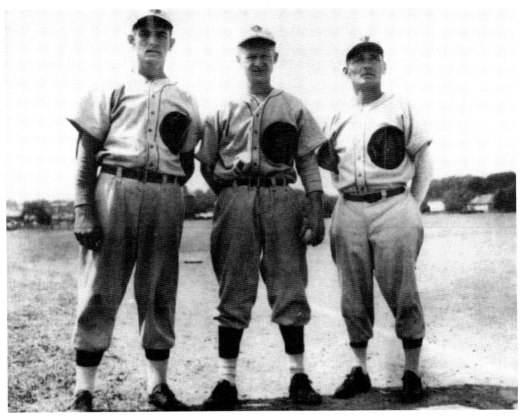

Reginaldo "Reggie" Nieblas (right) of San Juan Capistrano entered the US Army and served from 1942 to 1946. He became a technical sergeant in the 89th Division, 353rd Infantry, Company B. Sergeant Nieblas was the star pitcher of his Army baseball team during World War II. The other players seen here are not identified. (Courtesy of San Juan Capistrano Historical Society.)

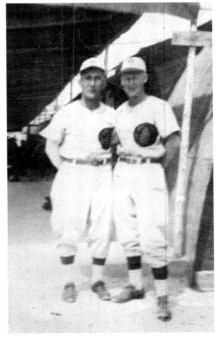

Reggie Nieblas (left) hurled for the Army throughout Europe, mostly in Germany and France. Here, he relaxes after a game outside a GI club in Europe with a teammate. After World War II, Nieblas returned home to San Juan Capistrano and became a volunteer fireman. He played on San Juan Capistrano's inter-station ball team, competing against other Orange County fire stations. Nieblas remained a volunteer fireman for over 30 years. (Courtesy of CeCe Nieblas-Vásquez.)

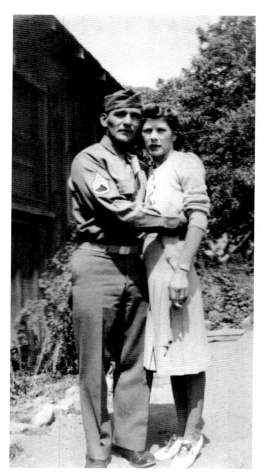

Reggie Nieblas was able to briefly return home from the US Army to San Juan Capistrano so he could marry his sweetheart, Louisa Manriquez, at Mission San Juan Capistrano. Reggie and Louisa were married on September 12, 1943. He soon after had to return to his Army and baseball duties in Europe. (Courtesy of CeCe Nieblas-Vásquez.)

The La Jolla Junior High School varsity Red Devils of Placentia won the 1939 Chamber of Commerce Cup. This photograph was taken at the field now known as McFadden Park, located at Valadez Middle School. Team members include, from left to right, (first row) Armando Castro, Tito Saucedo, Marcelino Guerrero, and Pimi Tovar; (second row) Carlos Felipe, Rudy García, Peter Rodarte, Joe Felipe, and unidentified. Domingo DeCasas is not pictured. (Courtesy of Monica DeCasas Patterson.)

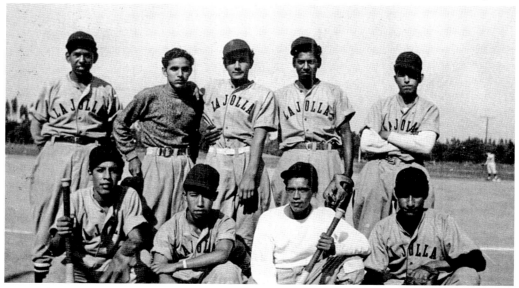

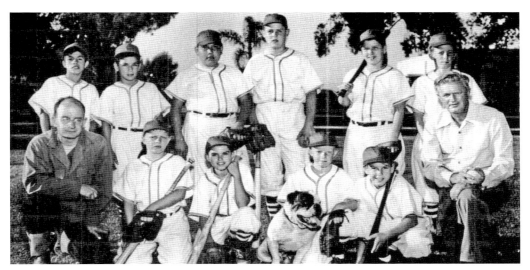

The Placentia Bull Dogs boys' softball team, seen here in the late 1940s, played for the La Jolla barrio. The Bull Dogs played at Bradford Field and competed against teams from Atwood, Brea, Fullerton, and Placentia. The Bull Dogs were managed by John Tynes (first row, far left) and coached by Elmer Williams (first row, far right). Mexican American players for the Bull Dogs were Albert Castillo (second row, far left), Danny Hernández (second row, second from left), and Ron Raya (second row, third from left). Not pictured are Jim Segovia, Willie Orosco, and Rudy Cisneros. The dog is Bonzo, the team mascot. (Courtesy of Jim Segovia.)

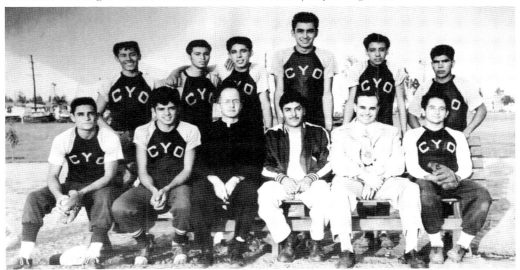

Catholic Youth Organization the original Road Kings baseball team was a group of boys who loved their cars—and baseball even more. Pictured with Father Kevin McNalley, the Road Kings came from Colonia 17 in Garden Grove and from Santa Ana. Due to the Korean War, the Road Kings disbanded until 1953. After the war, and with special thanks to Ray Casares, the Road Kings were once again together and playing in Santa Ana. Sadly, "Chano" Almazon did not return home. For every strike thrown in a game, Chano was remembered. (Courtesy of Richard Mendez.)

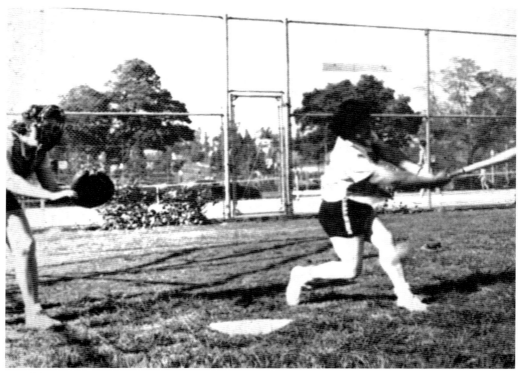

Geraldine Herrera, player for the Lady Hornets, is at bat for the 1950 Fullerton College women's softball team. (Courtesy of Fullerton Public Library.)

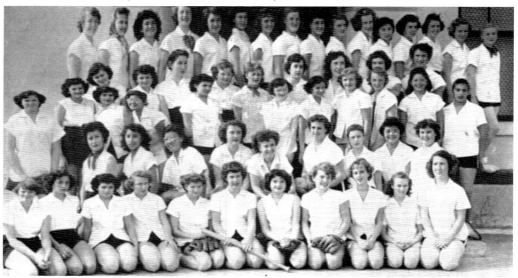

The Anaheim High School girls' softball team of 1951 features 56 members, including the following Mexican American players: D. Acosta, Herrera, López, Castrillo, Maldonado, García, Olvera, Contreras, Reveles, Gonzáles, R. Acosta, and Majera. The Lady Colonists looked to the 1951 season with great pride and determination. (Courtesy of Anaheim Public Library.)

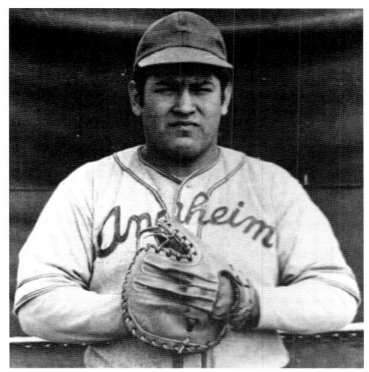

Eddie Herrera, a senior at Anaheim High School, was a rock-solid catcher. He looks fierce here while playing for the 1951 Anaheim High School varsity baseball team. Herrera was also the team captain, though the Colonists had a rough start to the season. While the team did not shine statistically, it developed into a fine ball club by the end of the season. After high school graduation, he went on to play baseball for Orange Coast College in Costa Mesa. (Courtesy of Anaheim Public Library.)

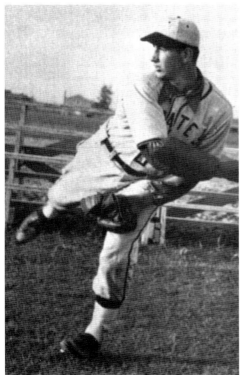

Rudy Casillas pitched and played for Valencia High School varsity baseball teams in Placentia between 1949 and 1951. In Rudy's senior year, he was selected as an all-league player. Rudy brought his pitching talents to the Orange Coast College baseball team in Costa Mesa. OCC started as a 243-acre site secured from the War Assets Administration in Washington, DC. The campus was carved from the 1,300-acre deactivated Santa Ana Army Base. OCC was built by a crew of 35 workers, mostly OCC football players paid 60¢ an hour. They converted an Army movie theater into an auditorium and concert hall, a service club into a 500-seat gymnasium, a military storage building into a library, an Army PX into a student center, and battalion headquarters into an administration building. In the picture, Rudy is in fine form after releasing a pitch for the 1952 OCC Pirates. (Courtesy of Orange Coast College Archives.)

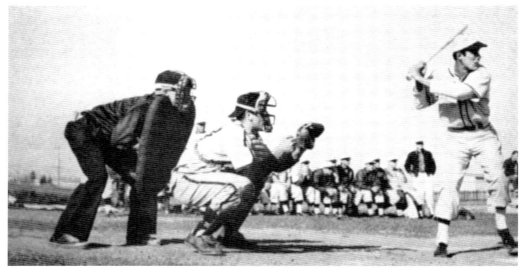

Berto Morales looks ready to knock the ball out of the park for the 1952 Orange Coast College Pirates in Costa Mesa. He played shortstop for the team. (Courtesy of Orange Coast College Archives.)

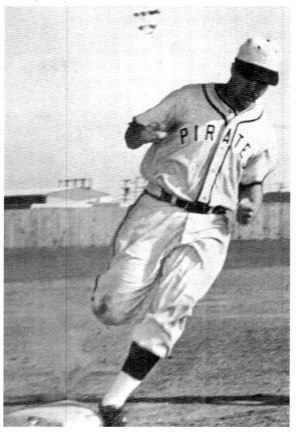

Wayne Braga, rounding third base, was a star player for the Orange Coast College baseball team in 1952 and 1953. In 1953, Wayne was selected as Orange Coast College Athlete of the Year and was ranked top in batting averages of the Eastern Junior College Conference. In March 1954, Wayne signed a contract and reported for spring training with the Boston Red Sox's California State League farm club. Wayne married Joann Farrington on September 26, 1954, at the Sacred Heart Church in Redlands. They have two boys, Dennis and Matt, who followed their father's footsteps in athletic abilities. Wayne worked for Stater Bros. for 40 years, retiring in 2000. Wayne and his two sons were inducted into the Redlands High School Athletic Hall of Fame in 2014, and in the same year, Wayne and Joann celebrated their 60th wedding anniversary. (Courtesy of Orange Coast College Archives.)

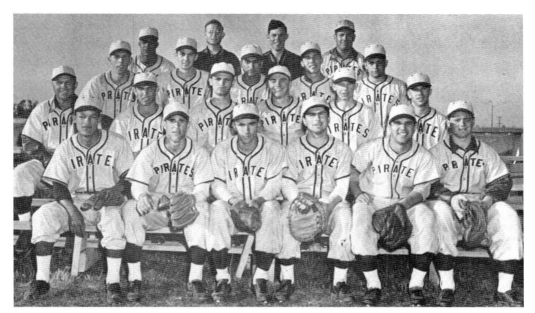

In addition to Wayne Braga, Rudy Casillas, and Berto Morales, the 1953 Orange Coast College Pirates of Costa Mesa features two other Mexican American players, brothers Ted (third row, third from left) and Eddie Herrera (fourth row, far right), catcher, of Anaheim High School fame. (Courtesy of Orange Coast College Archives.)

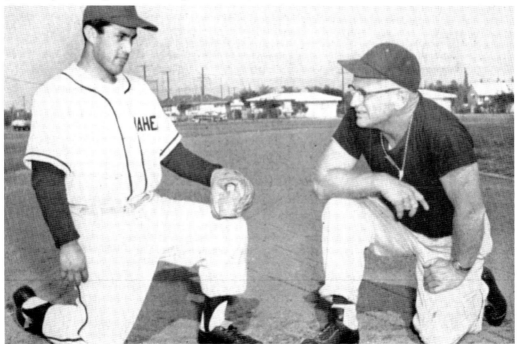

Player and captain for the 1954 Anaheim High School varsity baseball team, Lupe Gonzáles talks over plans for the next game with his unidentified coach. (Courtesy of Anaheim Public Library.)

This is the senior portrait of Paul Salazar at Anaheim High School in 1954. He did not play baseball for the Anaheim Colonists. A young and extremely talented pitcher, Salazar was recruited by top-notch city teams in the AAA and AA leagues in Anaheim, Fullerton, and Santa Ana, the latter in the Industrial League. Paul's athletic ability and passion for the game provided him with 40 years of baseball competition. Unfortunately, due to a home fire, all of Paul's baseball photographs were destroyed. (Courtesy of Anaheim Public Library.)

Jim Segovia was a pitcher on the Valencia High School Varsity baseball team in Placentia from 1952 to 1956. Valencia High School (VHS) was established in 1933 and shared buildings with Bradford Elementary School until 1964. Valencia High School had only one graduate in its class of 1934. Many of the VHS buildings were constructed during the Depression by the Works Progress Administration (WPA). In a candid moment in his living room, Jim shows off his baseball moves and uniform. By day, Jim pitched for Chapman College men's baseball team in Orange, and he would then rush home to change uniforms to pitch that night for Bob Jones Beer Bar softball team in Placentia. (Courtesy of Jim Segovia.)

Jim Segovia prepares to throw a pitch over home plate for the 1957 Chapman College baseball team in Orange. Jim was the leading pitcher for Chapman College (now Chapman University) from 1957 to 1960. Jim was under the direction of rookie coach P.R. Theibert in 1959–1960. Chapman University is a private nonprofit academic institution in Orange. Founded as Hesperian College, the school began classes in 1861. In 1920, the college was absorbed by California Christian College with classes held in Los Angeles. In 1934, the college was renamed Chapman College after chairman of the board of trustees C.C. Chapman. In 1954, Chapman College moved to its present campus in Orange. In addition to playing at the college, Jim was the assistant baseball coach for Chapman from 1960 to 1961. (Courtesy of Jim Segovia.)

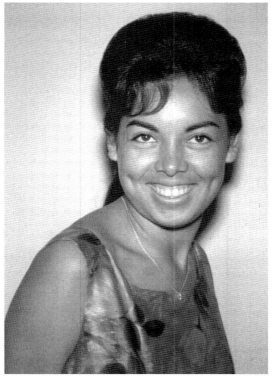

Edith Marval grew up in Colonia Santa Anita in Santa Ana. In 1958, Edith's family moved to Garden Grove, where she attended Garden Grove High School. Edith graduated from Bolsa Grande High School in 1961. In maintaining her connection to Colonia Santa Anita, Edith played for the Santa Ana Flames women's softball team with her cousins under the management of her uncle Paul Marval. Another of Edith's uncles, Luis Olivos, was connected to the historic Yost Theater in Santa Ana. In 1950, Luis leased the theater from owner Ed Yost to showcase movies from the Golden Age of Mexican Cinema. Edith married León "Zeke" Hallam on January 17, 1965. Edith and Zeke had two children, Sally and León. (Courtesy of Edith Marval-Hallam.)

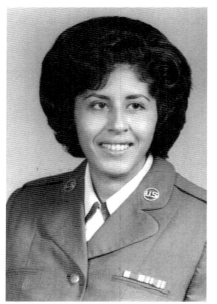

Maria T. Solis grew up in the Delhi barrio of Santa Ana, where her father worked at the Holly sugar-beet factory. Pictured in 1963, Maria was in the US Air Force from 1960 to 1967 and became an airman-AE master sergeant. Airman Solis played softball with teams at other Air Force bases wherever she was stationed. Solis was stationed in Puerto Rico when the Cuban missile crisis began, and she was evacuated back to America by orders from Pres. John F. Kennedy. (Courtesy of Maria T. Solis-Martínez.)

Pictured in 1966, Cecelia Ponce takes off to first base after a hit. The City of Orange Lions Club has been the proud sponsor of the legendary Orange Lionettes women's softball teams for decades. The Lionettes home stadium is at Hart Park. (Courtesy of Orange Public Library.)

6

FIELD OF DREAMS

Since its inception in 2006, the Latino Baseball History Project has sponsored countless events to recognize and pay tribute to those who played baseball and softball prior to the 1960s. Many of these players now range in age from the late 70s to the 90s. Recently, California State University–Channel Islands in Ventura County sponsored a month-long library exhibit on Mexican American women players. A panel discussion was held on March 25, 2015, honoring a handful of women who attended the event, including Marge Villa Cryan, Ernestina Navarro Hosaki, Virginia Ruiz Durazo, Mary Ramírez, and Agnes Trejo. Of this group, three of the women are in their 80s and two are in their 90s. Families and friends attended this remarkable event. The women signed baseballs and a bat, and took photographs with several people, especially young girls wearing their softball jerseys. The women participated in the traditional first-pitch ceremony in front of the library.

This event is typical of those that the Latino Baseball History Project has sponsored over the years. They allow these incredible ballplayers to share their stories to a whole new generation. Sandra Uribe, who is the leading national scholar on Mexican American women ballplayers, calls their public testimonies "like having Google speaking to us live." Many of the ballplayers who have helped build and support the project from its humble beginnings are sadly passing away. The project, the families, communities, and the nation are grateful and honored that these ballplayers have left their extraordinary stories to share with future generations.

Those who have recently passed away to play on the big diamond in the sky include Gilbert Gámez, Sal Toledo, Bobby "Babo" Castillo, Freddy González, Gilbert Belmúdez Sr., José G. Felipe, Ronald W. Venegas, Julián Barry Aguirre, Tony Villa, Ray Delgadillo, Joseph Cervantes, Carlos Felipe, George Encinas, Juan Sánchez, Della Ortega, Tony Almaguer, and Lupe Pérez.

This extraordinary lineup of deceased ballplayers represents the best of the country and among the best in the Mexican American community. They will be greatly missed by so many, but their legacy will live on forever, thanks, in large part, to the Latino Baseball History Project.

Juan Zapata, 93, poses with his great-grandchildren Ray Lozada Jr. (left) and Jonathan Lozada in 1998. Zapata played ball in Mexico in the 1920s and 1930s. The two boys were teammates from T-ball through high school. They attended San Ysidro High School in San Diego, where they were a part of the first team to build the baseball field. They both earned *Union-Tribune* all-academic honors. The two boys graduated in 2011 from Menlo College in the Silicon Valley in the city of Atherton. (Courtesy of Ray Lozada.)

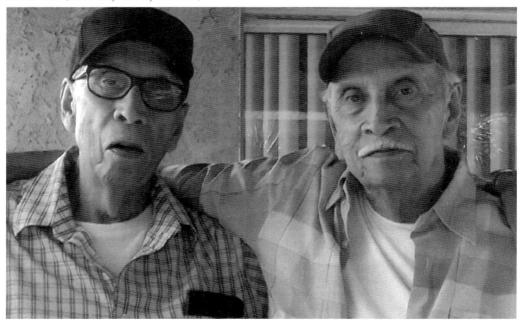

Ernie (left) and Manuel Abril, seen here in 2014, were outstanding players raised in Colton, California. They were star players for the famous Colton Mercuries. They played in Mexico, where they socialized with the great Mexican singer Pedro Infante. The brothers served in the Korean War, played military ball, and were part of the Army's Golden Dragons, escorting high-ranking military officers. They personally escorted Marilyn Monroe during her famous visit to Korea. (Courtesy of Ray Rodríguez.)

Della Ortega of San Fernando is holding a book in which she is pictured, in the top left photograph. In it, she appears in the second row, second from right. Considered athletic and beautiful, Ortega was the pitcher for the 1936 Azectas women's softball team from Pacoima. She was the only team member from San Fernando. Ortega was recruited by coach Chapo Vidal to pitch for the team. According to Ortega, playing ball enabled her to travel and meet young men, which she was not allowed to do at home. She passed away in 2014 at the age of 94. (Courtesy of Della Ortega.)

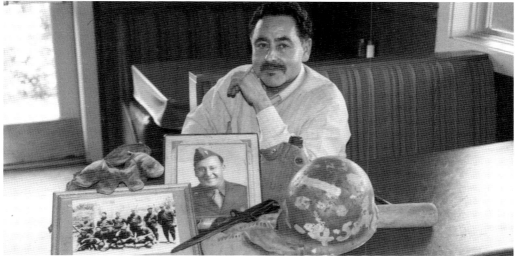

Juan Martínez shares his father's baseball and military memorabilia. John "Juan" Martínez was born in Fillmore, California, but played ball for nearly 40 years in the city of Gonzáles. He served in World War II, landing on Normandy during the D-day invasion with the Fourth Army, and later saw action at the Battle of the Bulge. He received the Purple Heart for being wounded twice. Martínez had two half brothers, Fermín and Gabriel Olivas, who also served in World War II. Gabriel was killed in action and is buried in Gonzáles. (Courtesy of Juan Martínez.)

The Aguirre, Henninger, De La Ossa, Jeffredo, Escobedo, Macias, Bateman, and Belleville families have a tradition of playing baseball in the San Gabriel Valley in California for over 100 years. These and other families continue to pass on this rich legacy of baseball to the younger generations in order to preserve and protect this history. Shown here are, from left to right, James Henninger Aguirre, Judy Bateman, Billie Henninger Jeffredo, Davey Escobedo, Lexi Macias, Philip Macias, Cory Belleville, Stephanie Belleville, and Lucille Henninger Aguirre. (Courtesy of James Henninger Aguirre.)

In December 2014, an event was held in Barrio Park in Claremont, California. The event honored Mexican American veterans and celebrated the release of the book *Mexican American Baseball in the Pomona Valley*. Nearly 250 people attended, sharing stories of loved ones who served in the military. State assemblyman Freddie Rodríguez and Victor Muñoz, field deputy for Assemblyman Chris Holden, presented certificates to the veterans and families. Several of the veterans had played military baseball during World War II and Korea. (Courtesy of Richard A. Santillán.)

In the summer of 2013, California State University–Pomona and the Latino Baseball History Project sponsored a three-month exhibit and hosted a luncheon for Mexican Americans who had played ball in the military. The exhibit included nearly 60 photographs of veterans who played during World War II, Korea, and Vietnam. Over 150 family members and friends witnessed each of the players receiving a special certificate. Here, Ray Delgadillo proudly shows off his certificate with family and friends. (Courtesy of the Latino Baseball History Project.)

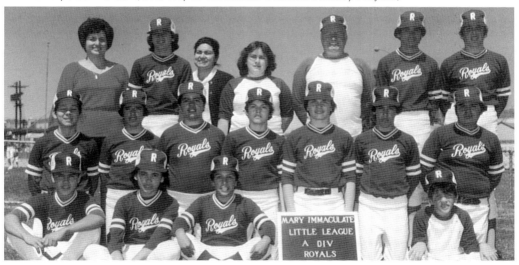

Following the legacy of his grandfather David F. Cruz, Michael O. Bacon played baseball for over 20 years, with his parents and sister assisting with managing, coaching, and score-keeping. The 1980 Royals team was one of many in a string of championship teams. Shown here are, from left to right, (first row) unidentified, David Mendoza, Héctor Castillo, and Steve Colella (batboy); (second row) Michael Bacon, Mario Quiroga, unidentified, David Sotello, Robert Margiotta, Robert Villaseñor, and unidentified; (third row) Yolanda Colella (sponsor), Raymond Ramírez, Alice (Cruz) Bacon (scorekeeper), Terry Bacon (coach), Ralph Bacon (manager), Bobby Ramírez, and Hugo Colella. (Courtesy of the Bacon family.)

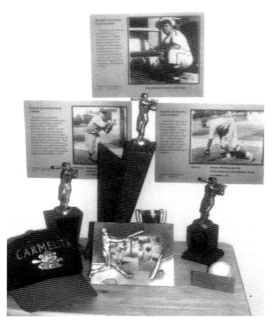

These photographs, trophies, and other mementos are just a few awarded to Ray Armenta during his five decades of playing baseball, and they are now included in the archives of the Latino Baseball History Project at California State University–San Bernardino. Armenta began playing on a variety of Los Angeles teams in 1929 at the age of 19. He was a member of the Carmelita Chorizeros (sausage makers) semiprofessional team. He was a versatile player at several positions and a specialist on drag bunting. (Courtesy of Bea Armenta Dever.)

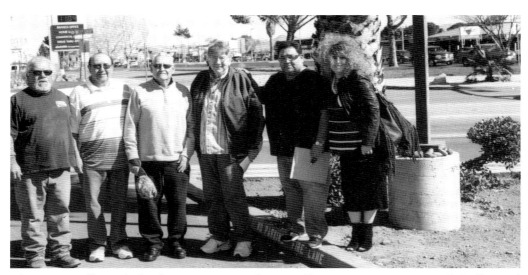

The Victor Valley includes the communities of Victorville, Barstow, Hesperia, Apple Valley, and Daggett. Most travelers pass these communities on their way to Las Vegas. Mexican Americans have deep roots in this area and experienced much discrimination and prejudice. Yet, they established long-lasting communities. In February 2015, a small group met in Victorville to share amazing baseball and softball photographs and stories. Shown here are, from left to right, Johnny Vacela, David Angel, Felix Díaz, Royce Beserra, Bob Quintanar, and Elisa Grajeda-Urmston. (Courtesy of Richard A. Santillán.)

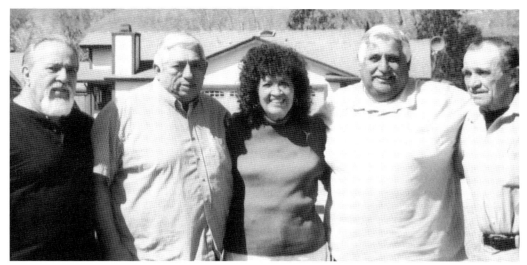

The Álvarez family dominated both baseball and softball in the South Central part of Los Angeles between the 1930s and 1950s. Here are, from left to right, Chito Álvarez, Remi Álvarez, Julia Álvarez-Forbes, Rudy Álvarez, and Johnny Forbes. Julia played sports while attending Roosevelt High School in the late 1940s. Remi played youth, high school, college, and military ball and enjoyed MVP and hall-of-fame honors. Rudy played ball, but he has devoted his time to being an umpire and basketball referee. Chito played and also umpired for years. (Courtesy of Remi Álvarez.)

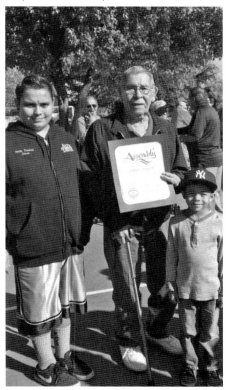

Tommie Encinas, age 92, is holding a certificate of recognition from the State of California in 2014 for his contributions to baseball and military service. His great-grandsons are Ronnie Morales (left), age 13, and Noah Sinay (right), age 5. Ronnie started playing baseball at four and at five played T-ball for the Upland Nationals and later for the Padres, Angels, and Indians. Tommie and his wife, Barbara, witnessed Ronnie hitting his first home run in an all-star game. Noah started playing T-ball at age 4. He played for the Orioles, Dodgers, and Angels. Ronnie and Noah are the grandchildren of Patti Encinas Garcia, Tommie and Barbara's only daughter. (Courtesy of the Encinas family.)

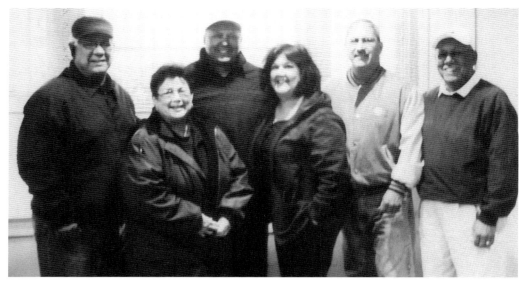

The Cervantes family from Sacramento, California, has produced several generations of ballplayers, dating to the 1930s. Here are, from left to right, siblings Eugene, Rachel, Edward, Cecilia, Eric, and Ernie Cervantes. Among them, they have played Little League, Babe Ruth, and American Legion, on church teams, and at the high school, college, and university levels. They have played semiprofessional and professional baseball in the United States and Mexico, as well as military ball. Their occupations included parole agent, counselor, teacher, vice principal, principal, and high school coach. (Courtesy of the Cervantes family.)

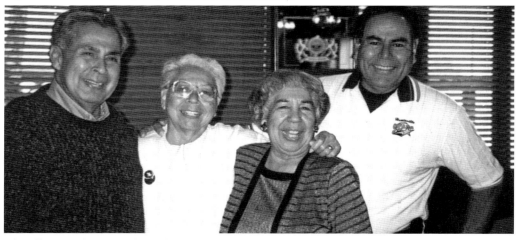

The all-star Salazar family includes, from left to right, David "Jimmie" Salazar, Eleanor (Salazar) Evans, Margaret (Salazar) Ashcraft, and Carlos Salazar. David pitched for Muir Junior College in Pasadena and in the US Army while stationed in Korea in 1951 with the 223rd Highballers. Eleanor (center field) and Margaret (shortstop) played softball for Muir Tech and for Carl's Shoes' Pasadena Ramblers. Carlos played at Muir High School and at Pasadena City College. Carlos and David extended their baseball careers by becoming umpires and often umpiring the same games. (Courtesy of the Salazar family archive.)

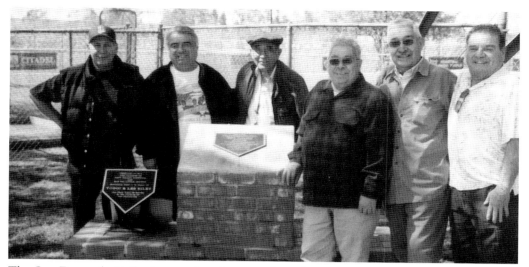

The San Fernando Valley has produced outstanding players, due to men and women devoting countless hours to youth baseball and softball. One of these individuals is Anthony "Tony" Servera Sr. The East Valley Pony League dedicated a field to Servera in 1965. The field was rededicated to the Servera family in 2008. Seen here are other individuals whose families have had generations of outstanding players and coaches. Posing are, from left to right, unidentified, Joffee García, Anthony Servera Sr., Fred Carrizosa, Anthony Servera Jr., and Mike Velarde. (Courtesy of Richard A. Santillán.)

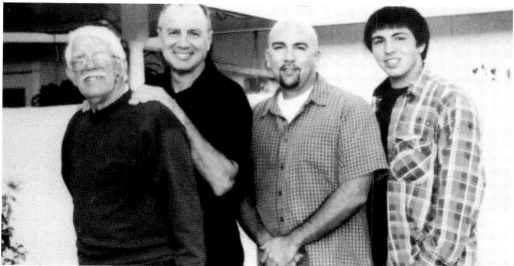

Here are, from left to right, four generations of Reyes players—Fidel Sr., Fidel "Phil" Jr., Justin Sr., and Justin Jr. Fidel Sr. was a catcher and practiced with his son, Phil, a left-handed pitcher. Fidel Jr. played Little League, junior high, and high school ball. He played at Centennial and Dominguez High Schools and Compton College. His son Justin Marion Reyes played junior high fastball and at Costa Mesa High School. His son Justin Jr. played Little League in Costa Mesa before joining the junior high school team. (Courtesy of Reyes family.)

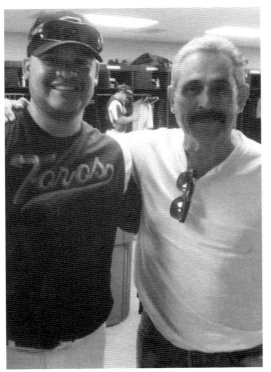

In this photograph taken in March 2015, Fernando Valenzuela Jr. is shown during spring training in Phoenix, Arizona. Fernando was playing for the Tijuana Toros and took time for a photograph with Ray Lara. (Courtesy of Ray Lara.)

The talented Prieto brothers, Eddie (left) and Pete (right), of Pacoima played baseball and softball for decades in the San Fernando Valley. They both served in the 2nd Marine Division during World War II. After the war, they formed the backbone of the Pacoima Athletics, helping the team win 14 straight games during one season. Pete worked as a police officer and detective for LAPD and later taught police-training courses after receiving his teaching credential from UCLA. Eddie worked as a California Highway Patrol officer for over 30 years. (Courtesy of Pete Prieto.)

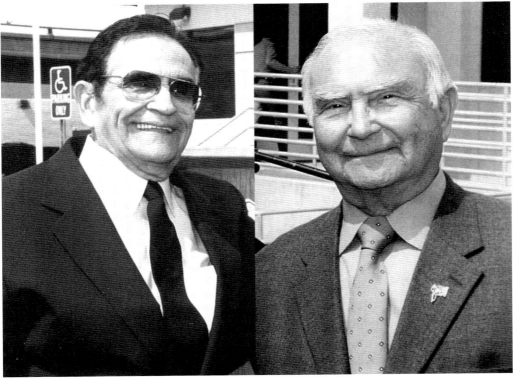

In October 2014, Mary Jane Muro holds a scorebook belonging to her father, Gene Madrid Tautimes. As a child, Mary Jane followed her father's games throughout the San Fernando Valley in the late 1940s and enjoyed keeping score in the dugout. Gene played outfield, pitcher, and catcher for numerous business-sponsored teams, such as Jolley's Used Cars, Phil Rauch Studebaker, Los Angeles Seals, Martínez Café, and Merchants. Besides a lifelong passion for baseball and softball, Gene founded the Twin Star disposal company. (Courtesy of Victoria C. Norton.)

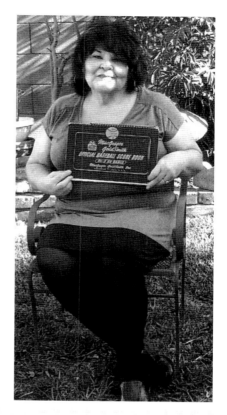

Moe Montañéz (back row, second from left) coached youth baseball in Glendale and Burbank throughout his life. He successfully fought for inclusion of Mexican American kids from Atwater Park in the Glendale Vaquero League. His motto was "No kid turned away," and he was the first coach in the league to draft a female player. On September 27, 2003, the City of Los Angeles dedicated the Richard "Moe" Montañéz Memorial Baseball Field in honor of the dedication of Richard and his wife, Marie. (Courtesy of Gloria Montañéz López.)

John Chávez from Planada, California, enjoyed an extraordinary career in baseball and softball. His daughters Amanda (left), Lucí (center), and Marisa Chávez (right) played on the Le Grand High School softball team in 1985. It is rare to have three sisters on the same team as starters, and this attests to their ability. They learned to love the game from watching their father, who taught them the basics. Amanda, a pitcher, played two years for Merced Community College. Her daughter, Jessica, was also a talented player at Le Grand High School for four years. (Courtesy of John Chávez.)

Posing with his two sons, Rossi (left) and Zachary, Randy Zaragoza is holding a photograph of his father, José Moises "Mousey" Zaragoza. This photograph hangs in the Stockton Mexican American Sports Hall of Fame. José was not allowed to play with white teams, so he and others formed their own team, the Latin American Club. In 1955, the Cal-Mex League was established. José later coached Little League and Babe Ruth teams, winning championships. He also started a girls' softball team in the early 1970s. José served twice in the military. (Courtesy of Randy Zaragoza.)

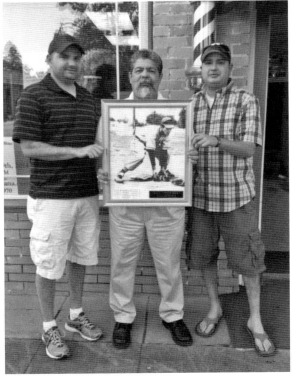

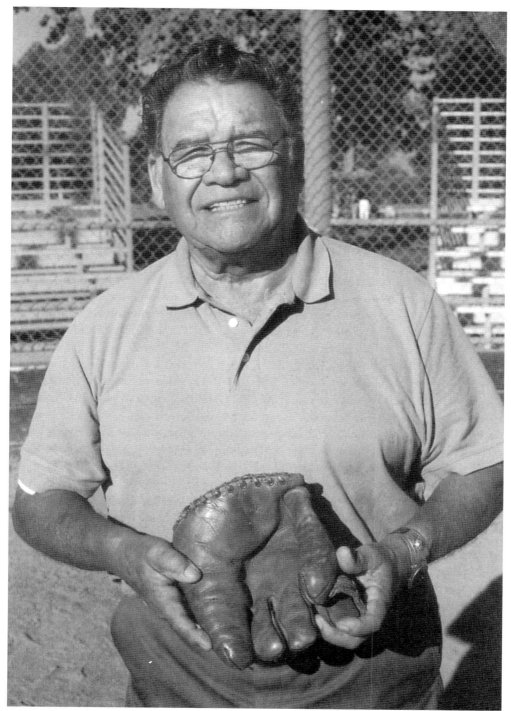

The first artifact donated to the Latino Baseball History Project was this glove, presented by Al Padilla in 2010. He used it in the 1940s. (Courtesy of the Latino Baseball History Project.)

BIBLIOGRAPHY

Arroyo, Pauline Cruz. Personal records and memorabilia: Cruz family of San Fernando. Unpublished and undated.
Barraclough, R. Laura. *Making the San Fernando Valley: Rural Landscapes, Urban Development, and White Privilege.* Athens: University of Georgia Press, 2011.
Digitized oral history interviews with "Shades of L.A." participants Ramona Frías and Della Ortega, Los Angeles Public Library, 1993.
García, Ricardo L. *Coal Camp Days: A Boy's Remembrance.* Albuquerque: University of New Mexico Press, 2001.
Keffer, Frank M. *History of San Fernando Valley In Two Parts, Narrative and Biographical.* Glendale, CA: Stillman Printing Company, 1934.
Los Angeles Herald Examiner Photograph Collection. Los Angeles Public Library.
Mass, Estella Lyon. Personal records and memorabilia: Lyon family of San Fernando. Unpublished and undated.
Mayers, Jackson. *The San Fernando Valley.* Walnut, CA: John D. McIntyre, 1976.
Mitchell, Rachel Cruz. San Fernando Baseball Team Simplex Score Book, 1921–1927, Completed Baseball Games and Baseball Schedules. Unpublished.
Mulholland, Catherine. *The Owensmouth Baby: The Making of a San Fernando Valley Town.* Northridge, CA: Santa Susana Press, 1987.
Murguía, Alejandro. *The Medicine of Memory: A Mexica Clan in California.* Austin: University of Texas Press, 2002.
Orange County, California, High School and College Yearbooks: 1920–1965.
Pauley, Kenneth E. and Pauley Carol M. *San Fernando, Rey de España: An Illustrated History.* 2005.
Robinson, William Wilcox. San Fernando Valley: A Calendar of Events 1938, Title Guarantee & Trust Company.
Roderick, Kevin. *The San Fernando Valley: America's Suburb.* Los Angeles: Los Angeles Times Press, 2001.

ADVISORY BOARD

José M. Alamillo, associate professor, California State University–Channel Islands
Eduardo B. Almada T., columnista y cronista megacable, Mexico and the United States
Richard Arroyo, valley historian and former San Fernando City historical commissioner
Gabriel "Tito" Ávila Jr., founding president/CEO, Hispanic Heritage Baseball Museum
Francisco E. Balderrama, professor, California State University–Los Angeles
Tomas Benítez, artist and art consultant
Anna Bermúdez, curator, Museum of Ventura County
Terry A. Cannon, executive director of the Baseball Reliquary
Grace Charles, archivist, Texas A&M University–Corpus Christi
Gene Chávez, Kansas Humanities Council Scholar

Raúl J. Córdova, dean, Los Angeles Trade-Technical College
Christopher Docter, graduate student in history, California State University–Northridge
Peter Drier, professor, Occidental College
Robert Elias, professor, University of San Francisco
Luís F. Fernández, public historian
Gregory Garrett, educational specialist, Institute of Texan Cultures, University of Texas–San Antonio
Jorge Iber, associate dean and professor, Texas Tech University
Alfonso Ledesma, Cucamonga Public Historian
Enrique M. López, University of California–Riverside
Jody L. and Gabriel A. López, Mexican American sugar beet labor/baseball historians, Rocky Mountain States
Susan C. Luévano, librarian, California State University–Long Beach
Amanda Magdalena, doctoral student in history, University of Buffalo
Douglas Monroy, Colorado College
Carlos Muñoz Jr., professor emeritus, University of California–Berkeley
Eddie Navarro, sports historian, Santa Maria
Victoria C. Norton, former historical commissioner, City of San Fernando
Mark A. Ocegueda, doctoral student in history, University of California–Irvine
Alan O'Connor, sports historian, Sacramento
Monica Ortez, public historian, Orange County
Al Ramos, public historian, Santa Maria Valley
Samuel O. Regalado, professor, California State University–Stanislaus
Alberto Rodríguez, assistant professor, Texas A&M University–Kingsville
Everto Ruiz, professor emeritus, California State University–Northridge
Vicki L. Ruiz, distinguished professor of history and Chicano/Latino studies, University of California–Irvine
Anthony Salazar, Latino Baseball Committee, Society of American Baseball Research
Richard A. Santillán, professor emeritus, California State University–Pomona
Marcelino Saucedo, public historian, Catalina Island
Joe Talaugon, Guadalupe Cultural Arts and Educational Center/Sports Hall of Fame
Carlos Tortolero, president, National Museum of Mexican Art, Chicago
Sandra L. Uribe, professor, Westwood College, South Bay Campus, Torrance, California
Alejo L. Vásquez, Cucamonga public historian
Angelina F. Veyna, professor, Santa Ana College
Alfonso Villanueva Jr., Árbol Verde Committee, Claremont

Discover Thousands of Local History Books
Featuring Millions of Vintage Images

Arcadia Publishing, the leading local history publisher in the United States, is committed to making history accessible and meaningful through publishing books that celebrate and preserve the heritage of America's people and places.

Find more books like this at
www.arcadiapublishing.com

Search for your hometown history, your old stomping grounds, and even your favorite sports team.

Consistent with our mission to preserve history on a local level, this book was printed in South Carolina on American-made paper and manufactured entirely in the United States. Products carrying the accredited Forest Stewardship Council (FSC) label are printed on 100 percent FSC-certified paper.